KAHLO

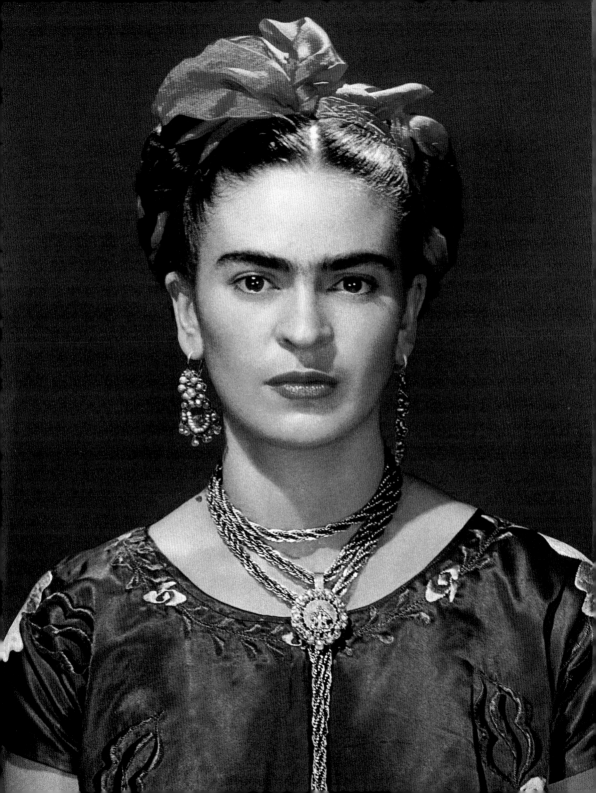

KAHLO

Eckhard Hollmann

PRESTEL

Munich · London · New York

Front Cover: Frida Kahlo, Self-Portrait
(dedicated to Dr. Leo Eloesser), 1940

© Prestel Verlag, Munich · London · New York, 2020,
A member of Verlagsgruppe Random House GmbH
Neumarkter Straße 28 · 81673 Munich

Editorial direction: Constanze Holler, Stella Christiansen
Translation: Jane Michael
Copyediting: Vanessa Magson-Mann, So to Speak, Icking
Production management: Andrea Cobré
Design: Florian Frohnholzer, Sofarobotnik
Typesetting: ew print & medien service gmbh
Seperations: Reproline mediateam
Printing and binding: Litotipografia Alcione, Lavis
Typeface: Cera Pro
Paper: 150g Profisilk

Verlagsgruppe Random House FSC® N001967

Printed in Italy

ISBN 978–3–7913–8657–7

www.prestel.com

CONTENTS

INTRODUCTION

There are many reasons why Frida Kahlo is famous far beyond the field of fine art, and why she became a "style icon". Frida Kahlo's artistic life was indeed determined by her illness, her complicated relationship with Diego Rivera, her numerous love affairs, her close links with Mexican folklore and her Communist beliefs. One question remains, however: does her extraordinary biography also explain the remarkable aspects of her art, her own concept of art as such, and her resulting unique personal style?

Frida Kahlo portrays her physical suffering clearly in many of her pictures. It did not determine her stylistic development, however, and the result was not a pessimistic depiction of misery. On the contrary: Kahlo's pictures are a defiant contradiction, a hymn to life. Her appalling accident and her constant battle against illness had a lasting effect on her life, but did not affect her artistic development and her idiosyncratic pictorial language.

The strong psychological pressure which Diego Rivera exerted on Kahlo was overpowering in every respect. He played games with her—often cruel games—and she obeyed him in a mental and physical dependence which can only be described as neurotic. "In her diary she speaks of the frustration of not being a perfect complement and companion for Rivera. She was tormented by what she felt to be her own inadequacies. They deluded her into daydreaming; her longing detached itself from a world which was subject to the compulsion of rational possibilities. Kahlo's message addresses the psyche and defies logical explanations. It reveals the extent of her passion for Rivera, her obsession with belonging to him and being with him for ever." Nonetheless, she did not follow him artistically and was never his "disciple". While she was very dependent on Rivera as a man, she remained completely independent from him with regard to his art.

Kahlo's encounter with the Surrealists in Paris shocked her permanently, but not in the sense that she was overwhelmed by their art. No, in fact, she was shocked by the lifestyle of the Parisian *bohème*. "They bluster on all the time about *culture, art, révolution* and all sorts of other things, imagining as they do so, that they are God himself. They dream up incredible nonsense and poison the air with their theories, when anyone knows that they will never be realised. The next morning they have nothing to eat in the house, because nobody works. They simply live like parasites on a group of rich show-offs, who admire what they conceive to be artistic genius. But all it really is, is shit."

Kahlo's numerous love affairs also influenced her artistic development. This circle of people has been largely ignored to date in literature on Frida Kahlo, but for her they were an essential part of her life. The subchapter "Companions, Friends and Lovers" is dedicated to them. Who were these people to whom Kahlo was attracted? She studied their artistic work without ever resorting to plagiarism; she drew on these sources, but nonetheless transformed their influence and adapted them to her own sense of style. The photographer Nickolas Muray, the graphic artist Fernando Fernández, the "muralist" Diego Rivera, the American avant-garde artist Georgia O'Keeffe, the Japanese-American artist and designer Isamu Noguchi and the Catalan painter José Bartoli left a deep impression on her life. However, this cannot be detected at all, or only in heavily disguised form, in Kahlo's pictures. It is likely that Frida Kahlo pursued these friendly and sexual relationships with highly interesting women and men, as a way of counterbalancing the compulsive relationship which chained her to Diego Rivera throughout her entire life.

Her links with her native country, Mexico, were deep and genuine. Kahlo often dressed in traditional costumes and was surrounded by selected items of Mexican folk art in her studio. She painted herself on several occasions wearing a "resplandor", the festive lace collar which frames the entire face. "Her resplendent Tehuana costumes, eye-catching headdresses, hand-painted corsets and prostheses skilfully masked her physical disabilities, and were also a form of self-presentation and an extension of her art." Frida Kahlo wanted to live nowhere else but in Mexico; it was the only country in which she felt able to live. Her ties to her native land were one of the few constants in her life and the most important source of her painting.

Rivera, who at one point was Secretary-General of the Communist Party of Mexico, introduced Kahlo into this left-wing intellectual world. His efforts met with only modest success, however: for Kahlo the Communist ideology became a naïve substitute religion. Her identification with this political conviction was of no significance for her art.

This book's aim is to show what constituted Kahlo's artistic independence and how hard she had to fight for artistic self-determination. Only in her late work was she able to truly discover herself; in her "painted diary" she freed herself of all shackles and her art became expressive and strongly abstracted. She threw all conventions to the wind and took no account of public taste or the opinion of her fellow artists, thereby overcoming not only her role model Rivera but also her penchant for folklore.

LIFE

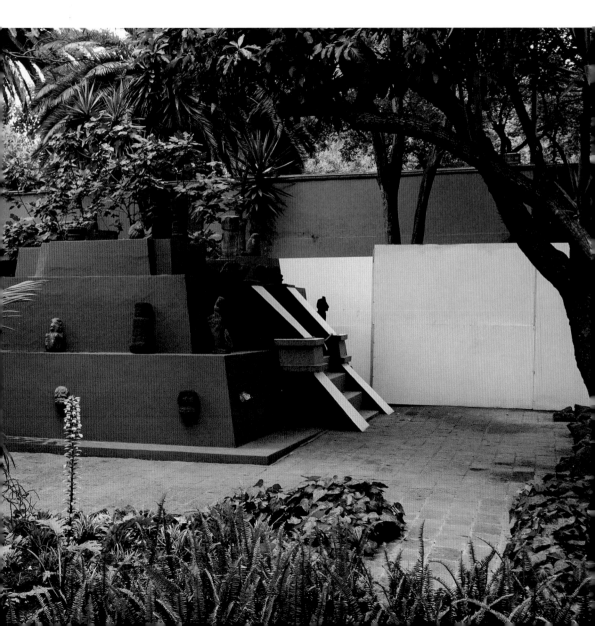

Frieda becomes Frida

A sheltered upbringing in the "Blue House": childhood and youth in Mexico 1907–1921

In retrospect Frida Kahlo's life appears highly unusual. However her childhood and youth in Mexico were normal and even unspectacular. Her father, Karl Wilhelm Kahlo, was born in 1871 into a middle-class family that lived in Pforzheim and later in Lichtental. Nothing is known of his schooldays. His eldest sister died in 1877 and his mother the following year. We can surmise that these tragic events must have been a hard blow for Karl Wilhelm and may have contributed to the boy's decision to leave his home country permanently. He set off for Mexico in 1890, soon after reaching adulthood. We do not know through whom or where he trained as a photographer, but the works he produced indicate that he focused on portrait photography from an early stage and that he was very knowledgeable in this field. He found a job with a jeweller and married María Cardeña Espino, with whom he had two daughters, Matilde and Adriana. Maria died in 1898 during the birth of their second daughter.

The stars were more favourable for Karl Wilhelm's second marriage to Matilde Calderón y Gonzáles during that same year. Wilhelm, who now called himself Guillermo, got on well with his new father-in-law, a famous photographer. Since Guillermo Kahlo had already begun to take an interest in the new medium of photography while he was still in Germany, he was pleased to accept his father-in-law's suggestion that he should accompany and assist him during an extensive photographic trip through Mexico. He became a highly respected photographer and his family was able to live from his work without financial worries. The construction of the "Blue House", in which Frida and her sister Cristina were to grow up, began in 1904. The single-storey building with three wings surrounded an attractive inner courtyard in which a garden had been planted—rather like a "hortus conclusus", an enclosed "Paradise Garden" of the kind that we recognise from the pictures of medieval masters. The house and garden became a sheltered space for Frida, remaining a retreat and the subject of many of her pictures throughout her life.

Frieda is listed in the register of births in Mexico City with the German spelling of her name which she later changed from "Frieda" to "Frida". She was her parents' elder daughter and born in 1907; her sister Cristina followed in 1908. "Frida maintained a close relationship with Cristina throughout her entire life, in which she, as the elder of the two—and later the successful one—called the tune. They attended kindergarten and school together and also agreed that they would regard their mother's religious convictions with scepticism and would even make fun of them at times." But Frida's carefree childhood was to be short-lived. At the age of six she became ill with polio, which confined the child to her bed for nine months. In those days polio was a severe

Karl Wilhelm ("Guillermo") Kahlo, *Self-portrait*, c. 1900

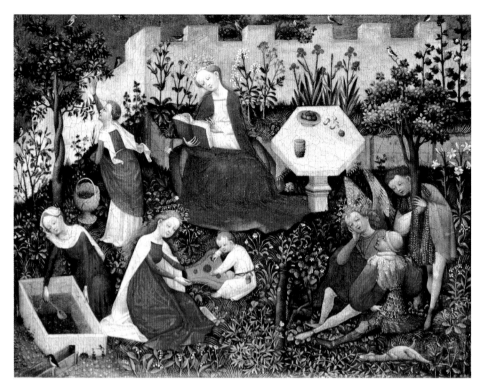

Upper Rhenish Master, *The Little Garden of Paradise*, c. 1410–1420

illness for which there was no protection; the corresponding vaccine was not developed until 1939. The consequence was a shortened right leg, which according to Frida was also "noticeably thinner than the left one. I also had to wear high lace-up shoes. At the beginning I took little notice of the jokes my school friends made about my leg, but later on their unkindness hurt me …"

An encounter with life: the "Prepa" and the "Cachuchas" 1922–1925

Frida's father lavished affection on her. They would go on walks together and he sparked her interest in literature and Mexican history. A keen amateur painter, he visited art exhibitions with his daughter and encouraged her wish to draw and paint herself. And he made a decision which would affect the course of Frida's life. In 1922 he enrolled her at the elite Escuela Nacional Preparatoria in Mexico City (the "Prepa"), a school whose main aim was to prepare gifted pupils to study at university. This privilege was largely the preserve of boys; the ratio of girls among the pupils was only about two percent. The Mexican writer Carlos Fuentes describes Frida Kahlo's role at this famous school as follows: "And so pretty little Frida […] with the fringe, the fluttering ribbons and the big bows suddenly became Frida Peg-Leg, *Frida pata de palo*. The mockery in the playground must have

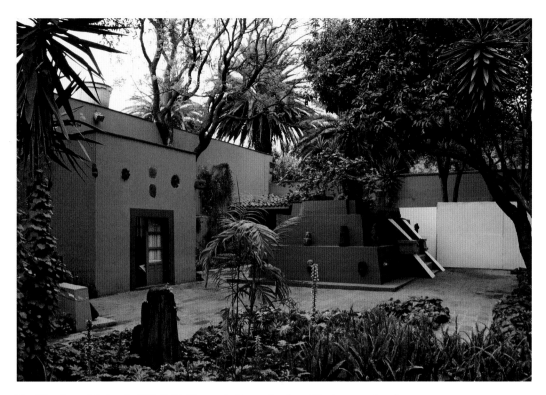

The "Blue House", today the Frida Kahlo Museum in Coyoacán, view of the inner courtyard

haunted her for the rest of her life. It did not throw her off course. She became the joker, the imp, the female Ariel at the National High School at a time when Mexico was discovering the indiscreet but liberating charm of the intuition of children and Indios." It was a time in which Mexico experienced an economic and cultural golden age. People looked back to the traditions of the indigenous population, researched Pre-Columbian Mexico and under the term "Mexicanidad" strove for a self-confident cultural and foreign policy that focused on their own history.

A wide range of different attitudes and political positions were to be found amongst the almost two thousand pupils at the school. Frida Kahlo was quite determined to join a group whose intellectual level satisfied her own demands, one which pursued left-wing ideals, represented unconventional views and took pleasure in provoking both teachers and the local populace. She found it in "Los Cachuchas". The word "cachucha" has a variety of meanings in Spanish: it describes a small boat and a solo dance from Andalusia resembling the bolero, but also refers to a cap worn by Andalusian farmers and shepherds. The seven boys and two girls in the group were referring to the latter, and their caps were intended to express their links with the people and their radically left-wing views. The young people read and discussed the works of their favourite authors,

who included the Mexican writers Mariano Azuela and Ramon López Velarde as well as the German philosophers Georg Wilhelm Friedrich Hegel and Immanuel Kant. They were not a quiet group of studious young people but had a thirst for life, and repeatedly attracted attention because of their escapades and provocative behaviour.

Their leader was Alejandro Gómez Arias (page 44). He has been described as highly intelligent and good-looking; he was also a brilliant speaker. A close relationship developed between Alejandro and Frida. He admired her waywardness, found it attractive when she dressed as a man and enjoyed discussing politics with her. They planned their escapades and political actions together and he valued her wilful stubbornness.

The two friends fell in love. Frida wrote in a letter to Alejandro dated 18 August 1924—she had celebrated her 17th birthday a few weeks previously—the theoretical basis for this step: "First assumption: Good friends should love each other very much. Second assumption: Alex and Friducha are good friends. Conclusion: Alex and Friducha should love each other very much."

During Frida's time at school another encounter took place which was to have a decisive effect on her life. In 1921 important representatives of Mexican monumental painting, known as "Muralismo", had been commissioned to decorate the Escuela Nacional Preparatoria with large-scale murals. One of the artists involved was Diego Rivera. He worked at the school on and off between 1921 and 1923, and one of his works was the large-format mural *The Creation*. Kahlo found this interesting and, on several occasions, slipped unobtrusively into the room in which Rivera was working. The artist also noticed her. "But it would never have occurred to me at that stage that she might one day become my wife."

Encounter with death: 17 September 1925

"Alex de mi vida" ("Alex of my life"), was the beginning of the letter which Frida Kahlo wrote to Alejandro Arias on 13 October 1925. She had already been in the Red Cross hospital for almost four weeks, but her boyfriend had not visited her. "You do not know how much I cried because of you, my Alex, and also because of my pain, because I tell you, during the early stages of treatment my hands were as white as chalk and I broke out into a sweat, it was so painful. [...] I was impaled all the way through, from my hip diagonally forwards; I was within a hair's breadth of being a cripple for the rest of my life, or I could have died; but now it is all over. One of the wounds has already healed and the doctor says that the other one will soon close up too. They must have told you what happened to me, didn't they? It will be a long time before my broken hip is healed, my elbow grows back together again and the smaller wounds on my foot have scarred over [...]. But I would give anything if you were to come instead of the people from Coyoacán and the women's group. I think I will simply have to kiss you when you stand before me; now I can see more clearly than ever how much I love you, and that I can never give you up."

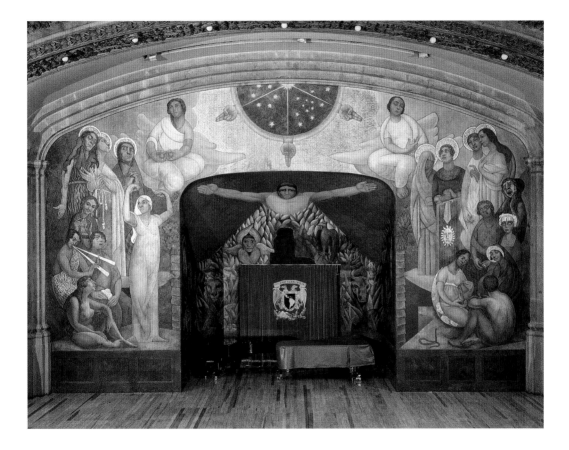

Diego Rivera, *The Creation* (mural), 1921/22

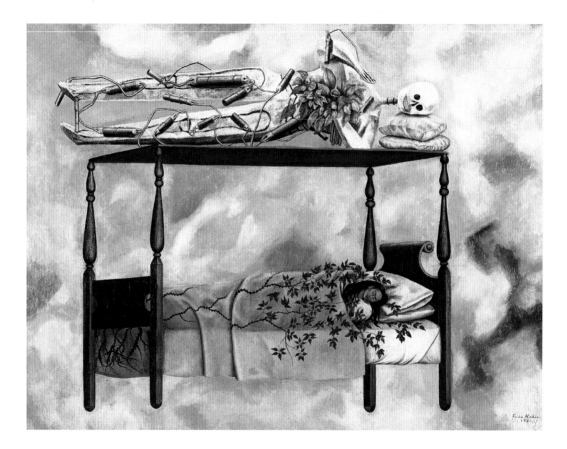

The Dream or *The Bed*, 1940

What had happened? On the afternoon of 17 September 1925 Frida and her boyfriend were sitting in a bus which was largely made of wood, on their way back home to Coyoacán from Mexico City, when there was a collision between the bus and a tram. Alejandro was thrown out onto the street, but Frida was trapped inside the bus; an iron grab pole which had come away pierced her body from behind and emerged again from her lower abdomen. A courageous fellow passenger pulled the rod out. Kahlo was taken to hospital, gravely injured. The doctors confirmed two fractures of the spine, three hip fractures, eleven fractures of her right foot, a dislocated elbow and serious internal injuries. Alejandro escaped with grazes and bruises. Frida Kahlo remained in hospital for four weeks, after which she was finally allowed to go home again, back to the "Blue House" in Coyoacán. But nothing was now as it had previously been. She had to spend most of her time in bed, suffered from severe pain and had to wear a plaster corset for some of the time. "I shall have to suffer this torture for another three or four months, and if it doesn't help, I really want to die, because then I cannot stand it anymore."

Disability, illness and death were now no longer abstract expressions for Frida but were to determine her life. They did not make her resigned—she was a fighter. And not in the sense of self-denial either; on the contrary: She embraced everything that she could experience in her life; she lived out her sexuality, repeatedly threw herself into new relationships, and celebrated life

in general. She set great store by what she wore, often experimenting and drawing inspiration both from Mexican folklore and feminine outfits from the United States. She sometimes appeared in an elegant three-piece men's suit. She is regarded today by many as a style icon.

In spite of her disability she travelled a great deal, actively supported the Communist Party, painted with increasing intensity and growing success, and became absorbed in and was consumed by her relationship with Diego Rivera, which however did not deter her from seeking other relationships and sexual contacts. But the vanitas motif would permeate her entire oeuvre and death remained a subject of her art until the end. It is possible that she more or less unconsciously attempted to counter the constant risk of death with something newborn in every picture that she completed.

Kahlo's painting The Dream (or The Bed) is a case in point. Frida Kahlo's canopied bed hovers in the clouds and the artist shows herself smiling and with closed eyes. A vine-like plant has grown over her blankets and already covers her body as she lies there. We instinctively think of Sleeping Beauty, slumbering as she awaits the knight on horseback who will rescue her. This thought is foiled by the dubious Judas figure, a symbol of death, which has stretched itself out on the canopy above the bed. Explosives are wound around its legs, and their ignition will be the cause of death. Instead of being rescued from sleep and demise by the knight's kiss, Frida is threatened instead with annihilation and death.

Encounter with Rivera: "The house is empty without you. Everything is dreadful without you."

But let us return to 1928, the year in which Frida Kahlo met the famous photographer Tina Modotti. Tina had arrived in America in 1913 at the age of 17, had worked in a textile factory in San Francisco and played minor acting roles in theatres in "Little Italy" there. In 1921 she had her breakthrough as both a model and an actress: Edward Weston, a famous photographer even in those days, took her on as a model. The professional relationship soon also became an intimate one. Weston left his wife and went to Mexico with his star model in 1923. It was there that Kahlo and Modotti met. The two soon became friends.

With regard to art they had many points in common, but what brought them closest together was their emphatically left-wing attitude. Modotti introduced Kahlo to the intellectual and artistic protagonists of the Communist Party. One of its prominent members was Diego Rivera, who immediately remembered the rebellious school-girl from the "Prepa". From now onwards until her death she would remain bound to this man, who challenged and promoted her, lied to and cheated her, fulfilled her every wish and destroyed her.

On 21 August 1929, just one year after their second meeting, Kahlo and Rivera married in the Town Hall of Coyoacán. The wedding celebration ended in total chaos; Diego was completely drunk and shot wildly in all directions with a revolver. Kahlo returned to her parents' house.

A short while later, however, the couple moved into a shared flat on the sophisticated Paseo de la Reforma in Mexico City.

The Struggle for Form

The paintings of Frida Kahlo can be divided into four basic groups of topics: self-portraits, other portraits, allegorical scenes and still lifes. In the major Symbolist compositions, familiar faces sometimes appear (*What I Saw in the Water* or *What Water Gave Me*, page 88), and some portraits make use of Surrealistic moments in order to characterise the figure more strongly (*Portrait of Luther Burbank*, page 27), but the genres are mostly separate and limited to the four groups listed above.

The main subject of Frida Kahlo's art is the artist herself! Her self-portraits remained the most important subject of her painting throughout her life; by contrast, most of the allegories—considerably influenced by her Paris sojourn and her contacts with the Surrealists—were created between 1938 and 1940, and the still lifes can be mainly attributed to the late 1940s and early 1950s. Her "painted diary", which she kept during the last ten years of her life, occupies a very special place in her oeuvre. Here she achieved a hitherto unknown artistic freedom and independence.

The Beginnings

A number of Frida Kahlo's drawings and paintings from the years 1924–1927 have survived. They are an indication of her early interest in fine art. However, the quality of these works is no more than what one might expect from a talented young person. A consistent artistic quality does not become apparent until 1928. The relationship with Rivera and the resulting contacts with the art scene sparked Kahlo's artistic ambition. From that point onward she wanted to become an artist, and at first she pursued her aim tentatively but before long with determination and energy. The picture *Portrait of Virginia (Niña)* (page 21), created in 1929, shows a girl seen in front view, sitting on an ordinary chair in front of a purple wall. Her face radiates an indeterminate melancholy. The floor and the wall divide the pictorial space horizontally, roughly in the middle. The picture is painted straightforwardly, in drastically simplified forms and with little three-dimensionality. But it is this simplification in particular, together with the relatively high degree of abstraction, that define the quality of the painting. It is touching in its sobriety and recalls, in its fundamental attitude, the works of Paula Modersohn-Becker, for example the *Girl with a Yellow Wreath in her Hair* from 1902.

The *Self-Portrait* (page 23) painted in 1930 evokes a similar effect. The figure has been shifted slightly away from the central axis, which marginally interrupts the rigour of the picture's composition. Both face and posture radiate profound concentration, as does the sober arrangement and colour scheme of the picture, which is restricted to tone-in-tone. We can see nothing here of the narrative elements, the attributes, the symbols and the various frills and fancies which we find in Kahlo's later "narrative pictures".

The American Way of Life 1930–1933

In December 1929 Diego Rivera received a tempting offer: he was commissioned by the American ambassador to Mexico to decorate the Palacio de Cortés in the city of Cuernavaca with frescoes. He accepted the offer. This "ingratiation with the class enemy" sparked a revolt among the leaders of the Communists, amongst whom Rivera still held the position of Secretary General. But the artist refused to recant. He resigned from office and left the Communist Party, and Kahlo left with him.

This meant that there was now nothing to stop them taking on major commissions from the United States. These were not lacking. Rivera was offered the opportunity to paint frescoes in the Stock Exchange tower in San Francisco and also in the California School of Fine Arts (later renamed the San Francisco Art Institute). Kahlo was delighted at the prospect of being able to live in the United States for an extended period, and so the couple planned a three-year sojourn in North America.

However, the year 1930 began traumatically: a miscarriage or a termination of pregnancy under medical supervision. The details are contradictory and it is virtually impossible today to determine what really happened.

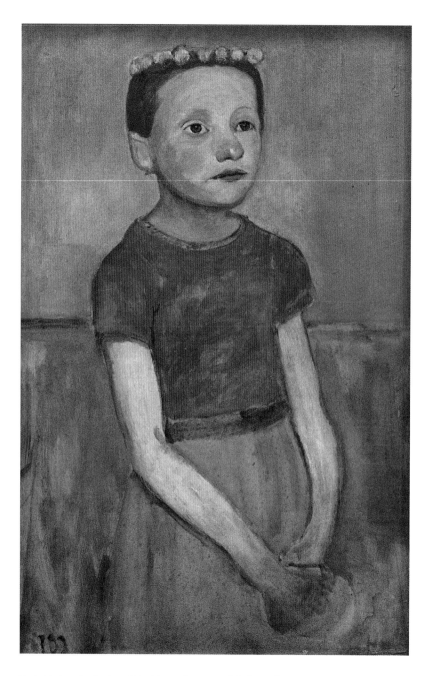

Paula Modersohn-Becker, *Girl with a Yellow Wreath in her Hair*, 1902

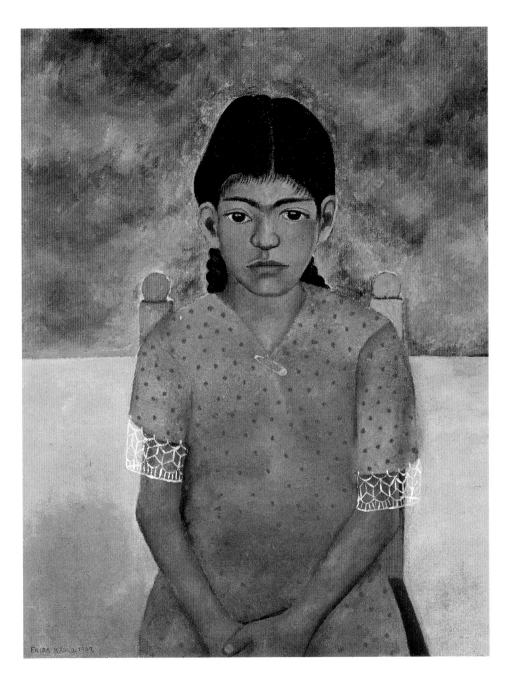

Portrait of Virginia (Niña), 1929

When the journey finally began in November 1930, Kahlo was full of happy anticipation. The couple's first destination was San Francisco, where Rivera soon began work on his large-scale fresco in the City Club. Apart from Rivera, all the artists working on the magnificent Art-Déco building were from the United States, and included Adeline Kent Howard, Robert Boardman Howard, Otis Oldfield, Ralph Stackpole and Clifford Wright. It is hardly surprising that the presence of the famous Communist artist from Mexico was the subject of gossip in San Francisco's society circles. The "exotic" couple appeared in public, was courted and received invitations. Accordingly, Kahlo became acquainted with a number of interesting conversation partners during the first months of her sojourn in California, especially the photographer Edward Weston and the surgeon Dr. Leo Eloesser.

Edward Henry Weston, one of the co-founders of the Group f/64, is regarded as one of the most important American photographers of the twentieth century. His landscapes, still lifes, portraits and nude photographs show him to have been a master of black-and-white photography. He used an 8-by-10-inch plate camera for the most part. His pictures were always expressive but never exaggerated, full of life, and American through and through. He had a low opinion of artistic theories: "To study the rules of composition before taking a picture is like studying the laws of gravity before going for a walk." This comment—whether substantiated or not—certainly reflects his artistic attitude very precisely.

In a diary entry dated 4 December 1930 Weston described seeing Diego Rivera again and his first impressions on meeting Frida Kahlo: "I took some photos of Diego, and also of his new wife—Frida: she is tiny—a doll beside Diego, but only as regards size, because she is a strong personality [...]. She wears Mexican clothing, even *huaraches* [traditional Mexican sandals], and when she walks through the streets of San Francisco in this costume, the people stop in their tracks and watch her pass."

The relationship which Kahlo established with Dr. Leo Eloesser was based on a very particular kind of trust. She contacted the consultant at the San Francisco General Hospital because of severe back pain and instinctively had confidence in him. From then onwards she asked his advice in all matters relating to health. In 1931 Kahlo painted the *Portrait of Dr. Leo Eloesser*, (page 24) on which he can be seen with a model ship. Eight years later—in the year of her separation from Diego Rivera—she gave Leo Eloesser a *Self-Portrait*, (page 25) to which she added a personal dedication. The inscription was: "Pinté mi retrato en el año de 1940 para el Doctor Leo Eloesser, mi médico y mi mejor amigo. Con todo mi cariño. Frida Kahlo" ("I painted my portrait in 1940 for Dr. Leo Eloesser, my doctor and best friend. With all my love. Frida Kahlo").

At first sight the two pictures go very well together: their colour scheme is strikingly similar. As regards form, however, they are worlds apart. In artistic terms nothing—absolutely nothing—is painted correctly in the portrait of Dr. Eloesser.

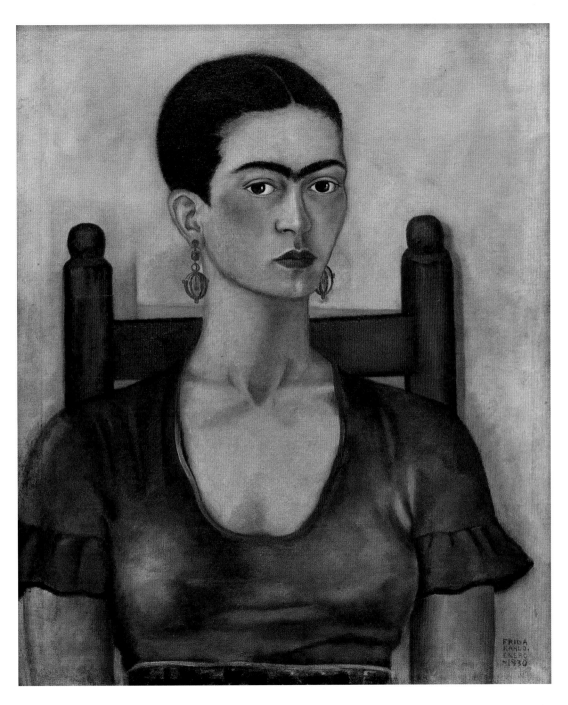

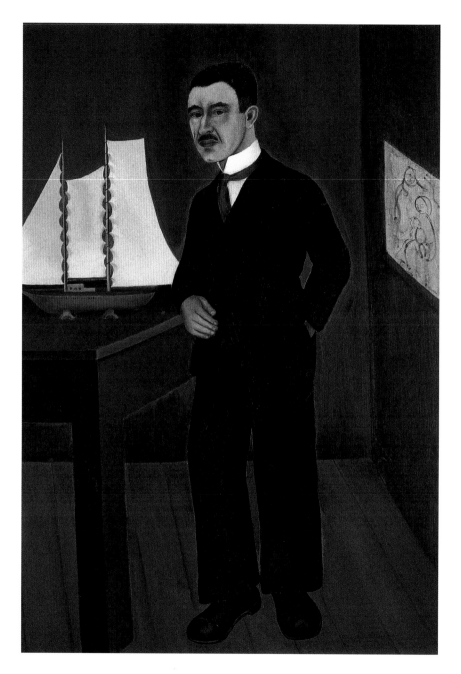

Portrait of Dr. Leo Eloesser, 1931

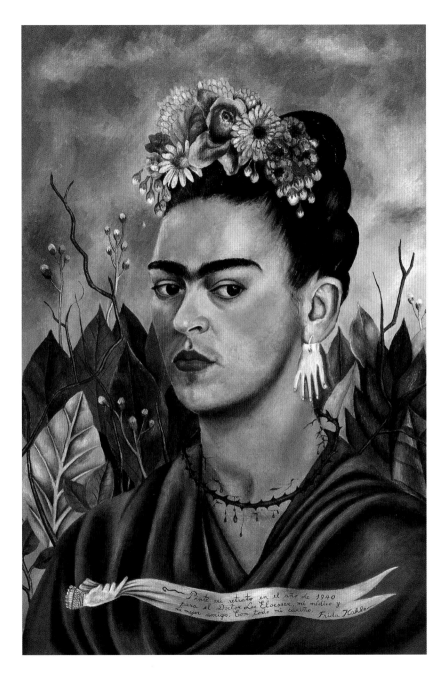

Self-Portrait (dedicated to Dr. Leo Eloesser), 1940

The head is not correctly positioned on the neck, the "little arms" are far too short, the position of the standing leg and the free leg has been drawn wrongly and the depiction of the perspective is "crazily shifted" in a very childish way. It is just not possible that Kahlo simply blundered with such blatant distortions; the portraits she had previously produced between 1926 and 1929 prove this. No, she clearly wanted to paint her revered personal physician in this "naive", innocent way, with the eyes of a child, free of veneration and even of sexual desire. He was her doctor, and she hoped he would heal and rescue her, just as a child expects help from its parents when it is in great need.

By contrast, her wonderfully painted self-portrait from 1940 is the complete opposite! The picture seems very self-contained, as regards both colour scheme and form. The palette extends from the bright red of her mouth via various shades of brownish-red in her face and clothing to the greenish brown of the leaves, which is interrupted by whitish shades. The sky, painted in fine nuances, takes up the entire colour palette once more in lighter shades.

Frida Kahlo looks earnestly and intently at the viewer. Despite the separation from Rivera, which was a source of great anguish for her, she looks composed and determined. As so often, she has flowers in her hair. The earrings in the form of human hands had been given to her by Pablo Picasso during her sojourn in Paris the previous year; she is wearing them in memory of better times. Only the necklace of thorns points to her

suffering and loneliness. The painting is a psychogram. Leo Eloesser, the recipient of the picture, will have known how to interpret it.

In April 1931 Rivera began work on the mural in the California School of Fine Arts. The art school was the most famous in the country at the time, a reputation it still enjoys today. Kahlo painted very little during this time but was satisfied with her role as "artist's wife". One of the few portraits from this year is that of Luther Burbank, a famous botanist and plant breeder, who had died back in 1926 and whose importance for American science was very similar to that of the naturalist Ivan Vladimirovich Michurin in the Soviet Union.

The strange painting is particularly important for Frida Kahlo's further artistic development because here, for the first time, she abandons the realistic viewpoint in her portraits in favour of a fantastic—if you will, Surrealist—picture arrangement. Luther Burbank had been buried beneath a tree, in line with his wishes. Kahlo paints his portrait with great precision based on a photograph; he is wearing a dark suit and is holding one of the hybrids he had bred in his hands. But the figure continues underground as the trunk of a tree with roots, which sucks its vital strength from a corpse—evidently his own. Death feeds life: Kahlo, who throughout her life had to fight against illness and the risk of death, would portray this metaphor pictorially in many variations.

From now on Frida Kahlo's art would focus more intensively than before on existential questions. She would examine various artistic movements of her time with the aim of establishing whether

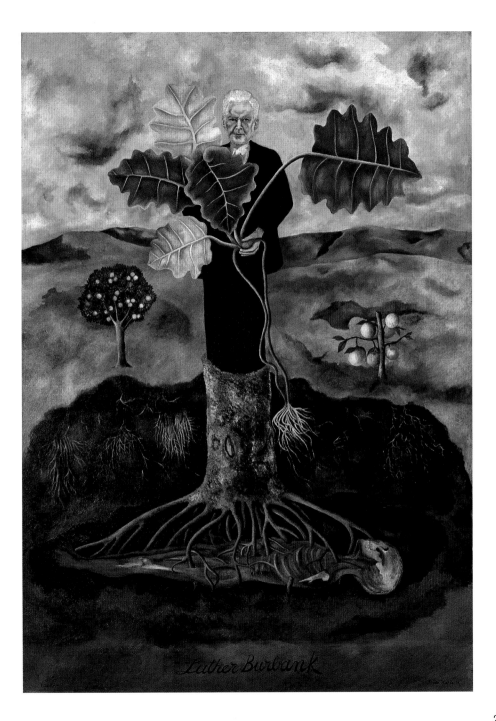

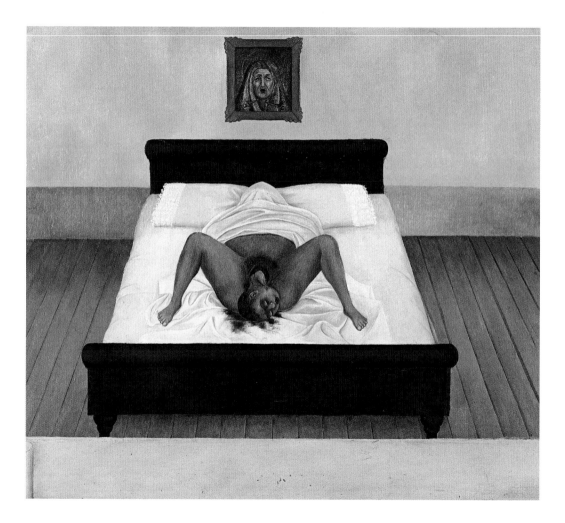

Birth or *My Birth*, 1932

they might be useful for her new aim of developing "simultaneous pictures" laden with content, and she would invent a new, delicate, Symbolist pictorial language which would enable her to depict complex topics.

In early June 1931 the two artists interrupted their sojourn in the United States and headed back to Mexico, where Diego Rivera was to finish the cycle of frescoes he had begun in the Palacio de Cortés. But before he was able to complete that commission, he received an important message from the United States: The Museum of Modern Art in New York, the world-famous MoMA, wanted to dedicate a major exhibition to his work! As an ambitious artist he could not ignore the invitation and so the artists returned to the United States in early November 1931. Before embarking on the journey, they commissioned a new house to be built in San Ángel, which they planned to move into when they finally returned home from the United States.

Rivera's exhibition opened in December and was a great success. He and Frida Kahlo rode on a wave of public interest. One evening, at a reception, Kahlo met the female sculptor Lucienne Bloch, who wanted to become Diego Rivera's assistant. After initial mistrust—Kahlo suspected, unjustly, that she might become a rival—the two women became close friends. It was at this time that she also made the acquaintance of the artist Georgia O'Keeffe, who was already very well-known in the United States. Even years later Rivera would relate with evident amusement how intensively Frida Kahlo had flirted with the American artist, almost twenty years older than she was, during a banquet one evening in New York (page 55).

During this time Kahlo mostly painted portraits: *Eva Frederic*, *Jean Wight*, *Luther Burbank* and the double portrait *Frida and Diego Rivera* (1931). Although she was unimpressed by life in the United States and suffered increasingly from homesickness, another two years would pass before she would finally return to Mexico. Rivera meanwhile rushed from success to success and from one love affair to the next. In April 1932 he started work on the frescoes in the Detroit Institute of Arts, and the couple had to move yet again.

It was to be a terrible year for Frida Kahlo. On 4 July a pregnancy ended in a miscarriage after four months. Kahlo was admitted to the Henry Ford Hospital in Detroit, where Lucienne Bloch visited her almost every day. In September she received the news that her mother was seriously ill. Together with Bloch, she set off for Mexico. Because no plane tickets were available they had to travel by train and bus, and finally arrived in Coyoacán on 8 September, where her mother died on 15 September 1932, seven days after her arrival.

Immediately after her return to the United States, Kahlo painted the picture *My Birth*. For this drastic, tersely formulated painting Hayden Herrera, Frida Kahlo's most important biographer, found a single comment: "In this picture [...] we see how the artist imagined the process of her birth. It is one of the most dreadful pictures of a birth ever to be painted." It is indeed a brutal

picture: we see within the same axis the portrait on the wall of the Virgin Mary, alienated into an ugly grimace, and beneath it the dead mother with the head of the newborn child between her legs attempting to escape from her lifeless body. In spite of the directness and brutality of the representation, the painting is designed as a votive picture. Especially the empty banner along the bottom edge, which should contain the intercessions, speaks for this assumption. And a second meaning is also to be found in this composition, one which we have already encountered in the portrait of *Luther Burbank*: death nourishes life!

Back in the United States, Kahlo had to come to terms with the fact that, like it or not, a joint life in Mexico with Rivera would not be possible in the foreseeable future. The mural artist was working hard on his frescoes in Detroit, which depicted the industrialisation of the American metropolis. Above all, however, the murals expressed his Communist attitude in no uncertain terms, which meant that the critical voices from the press and from the public were becoming ever more numerous. Nonetheless, the influential financier Edsel B. Ford was able to reject all attempts to prevent the completion of the pictures by pointing out the outstanding artistic quality of the works. Rivera found himself on the winning side: the fierce ideological and art-theoretical disputes in regard to the murals made the artist even more famous in the United States.

And so it was hardly surprising that a follow-up commission arrived from New York: Nelson Rockefeller offered the artist the job of decorating the entrance hall of the Rockefeller Center with frescoes. The construction work was still in full swing. And so, in March 1933, Rivera and Kahlo travelled to New York once again. During the course of the work here, too, the ideological conflicts between the artist and the client flared up once more: Rivera refused to paint over a larger-than-life-sized figure of Lenin. In May 1933 Rockefeller terminated the contract with the artist, paid him his entire fee and had the picture removed.

While Rivera was becoming increasingly demoralised by his work, the political disputes and his love affairs, Kahlo produced very little artistic work. Nonetheless, the few pictures which she created in 1932/33 show a remarkable artistic development. They became more complex and multi-layered. The artist remained faithful to her realistic, additive painting style, but expanded her subjects and content. Large numbers of figures and objects are now arranged in such a way that the pictures tell a story or convey a message. For the most part they could be easily deciphered, but sometimes they remained highly cryptic, such as her *Self-Portrait on the Borderline between Mexico and the United States*.

The return to Mexico 1933–1936

At last Frida Kahlo was able to breathe easily again. In December 1933 she and Rivera returned to their native Mexico. Kahlo was also looking forward to the new house in San Ángel, which in the meantime had been completed according

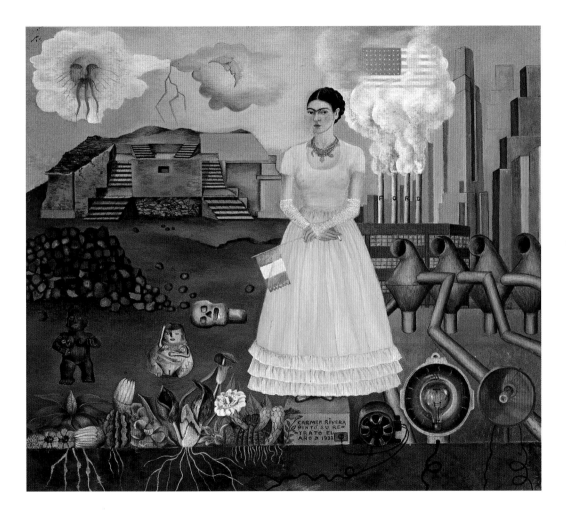

Self-Portrait on the Borderline between Mexico and the United States, 1932

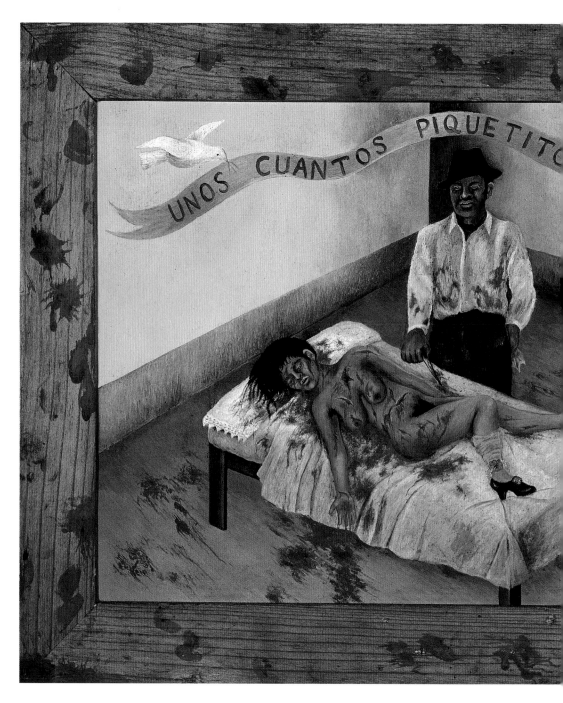

A Few Little Cuts, 1935

to plans by the architect Juan O'Gorman. The complex consisted of two flat-roofed buildings linked together by a gallery. Each section of the building was fitted out with a studio. This meant that the two artists could testify to their own individual independence while nonetheless living together.

Frida Kahlo was convinced that this lifestyle—linked together in liberty—would stabilise her relationship with Rivera. But her hopes were dashed in 1934, when Rivera started a relationship with her sister Cristina. She had been abandoned by her husband and lived with her two children in the "Blue House" in Coyoacán.

In addition to these mental and emotional problems, Kahlo had to cope with physical afflictions. She suffered another miscarriage and moreover the toes on her right foot had to be amputated because of gangrene. The liaison between her sister and Rivera ultimately resulted in Kahlo moving out of the house which she had occupied with such great expectations. In 1935 she rented a flat in the city.

Kahlo attempted to express her mental anguish in the picture *A Few Little Cuts* (page 32) from the same year. She did not paint herself, but rather some other woman whose garter is askew and whose high-heeled shoe on the right foot seems to indicate that she is a "woman of easy virtue". The man with the knife is an anonymous macho, but his face nonetheless reminds us of Rivera. Here Kahlo has transformed her tragic fate into a street ballad, a show piece. This "downsizing" may have happened subconsciously or she may have employed it intentionally: held up to ridicule, the events lose their ability to shock.

In July 1935 Kahlo decided to travel to New York with two girlfriends to pay a visit to Lucienne Bloch. We must not forget that in those days the journey represented a real challenge. After all, New York and Mexico City lie some three thousand kilometres apart as the crow flies, and the shortest overland route is over one thousand kilometres longer.

We can imagine that Kahlo hoped that she would be able to overcome her deep depression in another environment and without the proximity to Rivera and her sister. This was no doubt also the reason for the liaison which she had entered into with the Japanese-American sculptor Isamu Noguchi after her return at the end of the year (page 65). Nonetheless her relationship with Rivera became somewhat easier, which can no doubt be attributed to the fact that they both focused their attention on their political activities once more. The Civil War had started in Spain in 1936; Rivera and Kahlo wanted to support the Spanish popular front and formed a solidarity committee. Rivera had close links with the Trotskyist Fourth Internationale and was able to convince President Lázaro Cárdenas of Mexico to grant political asylum to the Russian politician Leon Trotsky, who had fallen out with Stalin. Frida Kahlo placed the "Blue House"—which had no fewer than fourteen rooms—at the disposal of Trotsky and his wife Natalia Sedova. In January 1937 Frida Kahlo began a love affair with the Soviet politician which would last for about six months (page 67).

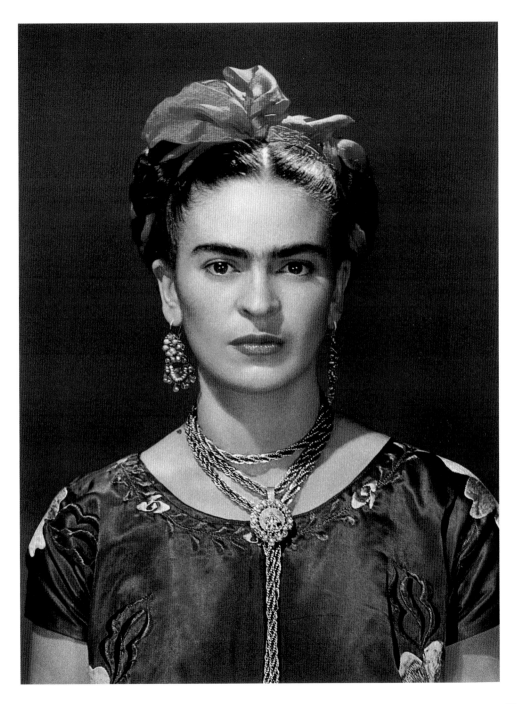

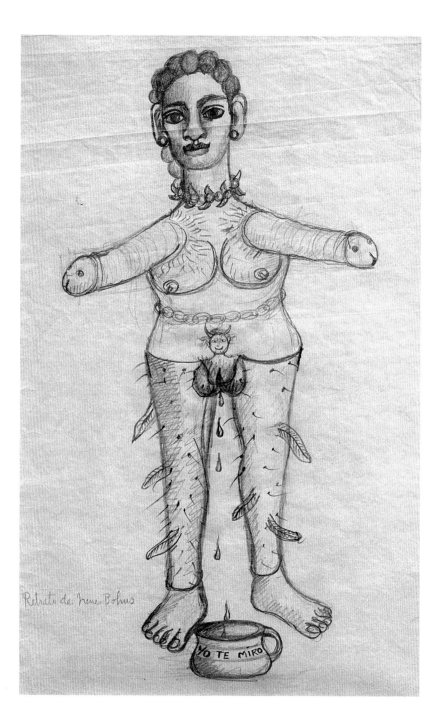

Retrato de Irene Bohus

Portrait of Irene Bohus (I Am Watching You), 1947

Going her own way and artistic maturity 1937–1943

In spite of the confusion associated with her personal relationships Kahlo intensified her artistic work during this time and was finally able to achieve growing recognition. The art dealer Julien Levy invited her to present a solo exhibition in his New York gallery from 1–15 November 1938. Kahlo was delighted! She set off for the United States alone. The success of the exhibition was more than she had dared hope for. She wrote enthusiastically to her childhood friend Alejandro Gómez Arias: "It all went wonderfully well, I really am incredibly lucky. […] The gallery is first class and they have hung the pictures very well."

And she experienced more "incredible luck" during this period. Kahlo fell in love with Julien Levy, and shortly afterwards with Nickolas Muray, a successful photographer and Olympic sabreur of Jewish-Hungarian origins. She had previously met him in 1931 on one of his frequent trips to Mexico, and now they became lovers.

In January 1939 Kahlo travelled from New York to Paris at the invitation of the writer André Breton, the protagonist of Surrealism in France. She had high expectations, since an exhibition of her works was to take place there. But nothing had been prepared and she was repulsed by the lifestyle of the Parisian artists. She wrote in disgust to Nickolas Muray: "I swear to you that I shall hate this place and the people who live here for the rest of my life. There is something false and phony about them, it is making me go mad …

I just hope I shall soon be well enough to be able to escape from here."

She eventually exhibited fifteen pictures in a Mexico exhibition in the Galerie Renou & Colle in March. The Louvre purchased one of them. It was a remarkable success when we remember that until that point Frida Kahlo had been more or less unknown in Paris. Words of acknowledgement and congratulation from "great shits" like Joan Miró, Wassily Kandinsky, Pablo Picasso and Yves Tanguy reconciled Kahlo, but she still left immediately after the exhibition was over, initially back to New York and from there in April on to Mexico. One reason for her sudden return home was the abrupt end of her liaison with Nickolas Muray (page 56).

Now Frida Kahlo was looking forward to seeing Diego Rivera again. As early as January 1939 she had written to him: "I need you as I need air to breathe—it is really a sacrifice for me to go to Europe, because I want to have my boy with me." Their reunion was more than disappointing, however. At this point Rivera had two lovers, Irene Bohus and the American actress Paulette Goddard. Moreover, he was not willing to forgive Kahlo for her affair with Leon Trotsky which he had learned about in the meantime. Whatever the deciding factor may have been, the couple filed for divorce which became absolute on 6 November 1939. By this stage Kahlo had already left the home they shared in San Ángel and had returned to her parents' house in Coyoacán.

Kahlo's resentment of Irene Bohus was particularly long-lasting. Eight years after the liaison between Diego Rivera and the American diva she painted the acrimonious *Portrait of Irene Bohus* (page 36). She shows her former rival naked; her arms are phalluses, her genitals are shown as an androgynous, grinning devil; her urine is dripping into a chamber pot with the inscription "Yo te miro"—"I am watching you". It sounds like a threat.

In the year of her divorce, Kahlo completed a painting which broaches the subject of her separation from Rivera. *The Two Fridas* describes a schizophrenic situation: against a dramatic sky two women are sitting side by side, who are nonetheless one person. The Frida on the right is wearing Mexican costume and holding a medallion with a portrait of her beloved Diego Rivera as a child in her hand; her heart is joined to it by an artery. The Frida on the left, in her wedding dress, is the outcast; her heart is damaged and the artery ends in mid-air, with her blood dripping into her lap, and the medallion with the portrait of Rivera is missing. She is trying to stop the bleeding with a surgical clamp.

Artistically speaking, 1940 brought Frida Kahlo some striking successes: she exhibited two pictures at the International Surrealism Exhibition in the Galería de Arte Mexicano and participated in presentations in San Francisco and New York. But then she received yet another piece of devastating news: Leon Trotsky had been the victim of an assassination in Coyoacán. Kahlo and her sister were detained by the police for several hours and questioned, since it was known that Kahlo and the Russian revolutionary had had an affair in 1937 and that she knew Ramón Mercader, Trotsky's murderer.

In September the doctors diagnosed a kidney infection and anaemia. Kahlo's state of health deteriorated rapidly. In a psychological assessment that was carried out in 1949/50, it was noted: "It is known that at times Kahlo consumed large amounts of alcohol, sometimes almost an entire bottle of brandy in a single day, evidently in an attempt to relieve her chronic pain."

Diego Rivera had already left for San Francisco in August in order to paint his mural *Pan American Unity* during the Golden Gate International Exposition. The artist worked in public and visitors were able to watch him painting. This "Art in Action" was extremely unusual at the time and attracted many curious viewers.

In the meantime, Frida Kahlo had re-established contact with Dr. Leo Eloesser once more. He instructed her to come to San Francisco so that he could treat her. He disagreed with the methods of treatment adopted by her doctors in Mexico, and he also urged her to agree to a reconciliation with Rivera. Only then would her state of health improve in the long term. He had recognised how difficult Kahlo found it to live together with Rivera, but he also realised that their separation would have even worse consequences for her. After some hesitation she decided to follow her doctor's advice and travelled to San Francisco in September 1940. She entrusted herself to Dr. Eloesser's care in Saint Luke's Hospital.

The Two Fridas, 1939

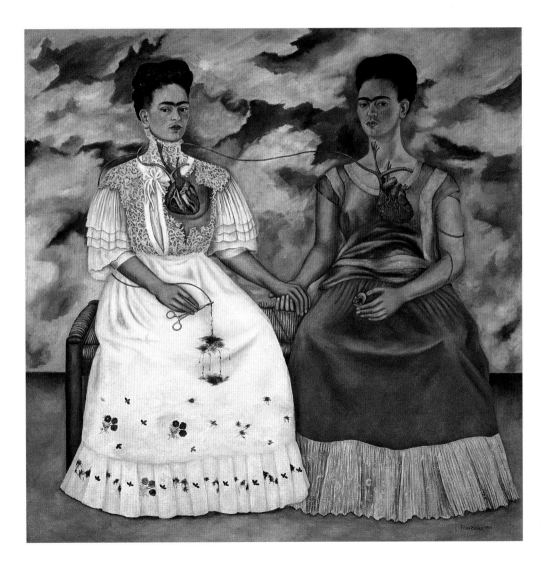

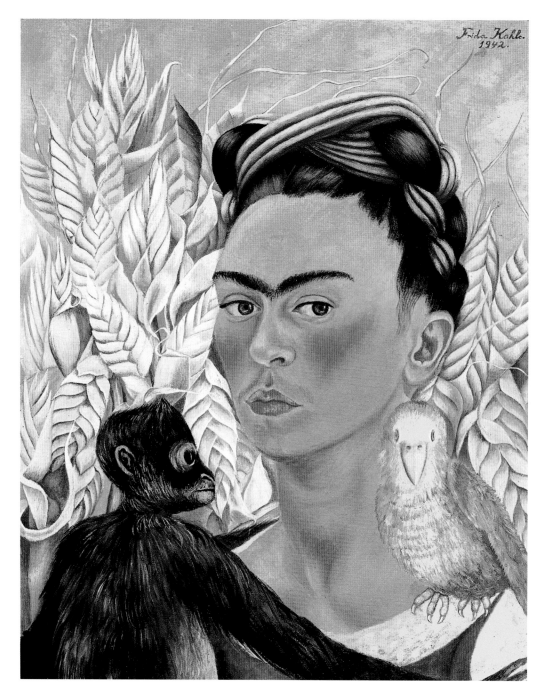

40

Rivera visited her there frequently, often accompanied by an attractive young man. Kahlo immediately fell in love and began an affair with him even while she was still in hospital. He was the later art collector and patron Heinz Berggruen (page 71). In spite of this passionate amorous intermezzo Kahlo and Rivera were reconciled — and Berggruen left, disappointed.

Frida Kahlo and Diego Rivera were married for the second time on 8 December 1940 and returned to Mexico. They lived together in the "Blue House" in Coyoacán, while the studio house in San Ángel remained Rivera's realm alone. Kahlo worked on her paintings almost every morning, and her life with Rivera was largely free of tension. "But far beneath the surface, the relationship of the Riveras was threatened by serious problems. Kahlo's physical weakness, her uncontrolled jealousy and her desire to possess her husband completely were all diametrically opposed to his personal disposition. He loved Kahlo, but not in the way that she wanted to be loved. Rivera was restless and difficult to understand. He cut himself off emotionally and was repeatedly unfaithful."

The death of Frida Kahlo's father on 14 April 1941 was a heavy blow for her. She wrote to Dr. Eloesser that she was not at all well and was losing weight again. And she described her relationship with her parents to the psychologist Olga Campos: "He was handsome and was a very noble man. She was pretty too. He was very intelligent, and so was she, although lacking in education. I loved my father, because he was good to me, and because he helped me. And I loved her, because I saw her suffer."

In 1942 Frida Kahlo was appointed as a teacher at the La Esmeralda Art Academy. In spite of her poor state of health—her spine, which had only been stabilised with difficulty, was extremely painful and she had to wear a steel corset—she travelled to Mexico City three times a week in order to teach. She made suggestions and corrections and even sat as a model for her students, almost always in Mexican dress, allowing them to draw her. She also used photos as teaching material and taught her students how to produce art in the same way as she did it herself.

When the pain increased she offered to continue teaching her students at home. At the beginning almost the entire class came, but the numbers dwindled, for the journey from the capital to Coyoacán was too far for most of them. Four students remained loyal to her; they were known as "Los Fridas". Later they became some of the founding members of the Group of Young Revolutionary Artists in Mexico. During this time Kahlo's self-portraits were virtually the only paintings she made, together with a few still lifes.

In her self-portraits, Kahlo liked to depict herself together with animals. One might presume that they had a symbolic character, but this assumption was at variance with Kahlo's own statements. She wrote specifically that she had never believed in animals possessing magical powers. She was fascinated by painting animals for a very different reason: "I am repeatedly surprised to observe the similarities in the faces of people and animals."

Frida Kahlo's self-portraits are extremely popular on the art market. In 2005 her *Self-Portrait with Monkey and Parrot* (page 40) was sold for more than three million dollars at Sotheby's in New York. "But the chance of acquiring one of her works is slender. Frida Kahlo died at the age of only 47. Her oeuvre is small, consisting of some 280 paintings and drawings, and a considerable number of them are preserved in her museum in Mexico. If one of her works is offered for sale on the market it is celebrated as an event, and people are amazed at the price. [...] In 2000 an American collector paid over five million at Sotheby's for an early self-portrait. Never before had an artwork by a woman achieved such a remarkable amount."

"Tree of hope, keep strong" 1944–1954

"Frida Kahlo was a shattered Cleopatra, who concealed her martyred body, her crippled leg, her broken foot and her orthopaedic corset under the spectacular finery of Mexican peasant women, who carefully guarded their ancient jewellery from poverty over the centuries, then bringing it out on local, rural festive days. The ribbons, the bows, the skirts, the rustling petticoats, the lace, the moon-like hairstyles which framed her face like the wings of a dark-coloured butterfly: Frida Kahlo showed us all that her endless diversity was neither withered by her suffering nor atrophied by her illness."

The numerous operations, which brought her only temporary relief but not healing as well as the succession of miscarriages and abortions in addition to her mental problems, this all weakened Kahlo's resistance. She now placed all of her hopes in the New York "bone surgeon" Dr Philip Wilson, who had read her clinical history and was prepared to operate in order to stabilise her spine. In June 1946 she underwent the complicated operation in New York: four vertebrae were fused together and a piece of metal was implanted. She wrote to her childhood friend Alex: "It is already three weeks since the cutting and bone-sawing took place. This doctor is wonderful and my body is so full of vigour that they have already had me standing on my own two feet for two minutes. I can hardly believe it!"

That same year she painted the picture *Tree of Hope, Keep Strong*, which gives expression to both her positive expectations and her fears for the future. As in the case of *The Two Fridas* it is a simultaneous picture: in a devastated landscape riddled with abysses, Kahlo is lying on her sickbed on the "sunny side". She has turned her back towards the viewer so that we can see the two long incisions that were made during the operation. On the dark "moon side" of the picture, Kahlo is sitting in a traditional red dress. She shows us her corset and is holding a flag in her right hand with the message "Árbol de la esperanza, mantente firme" ("Tree of Hope, Keep Strong").

In spite of her physical and mental suffering, there was virtually no change in Frida Kahlo's

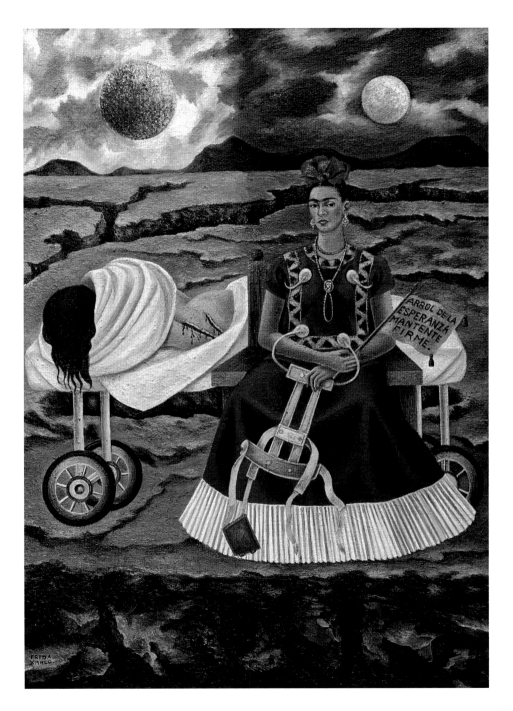

Frida Kahlo, *Portrait of Alejandro Gómez Arias*, 1928

relationship to Rivera. He continued to pursue his amorous adventures while Kahlo was hardly in a position to enter into sexual relationships, due to her physical condition. Nonetheless there are a number of references to a relationship with a Spanish immigrant which is said to have lasted from 1946 until 1952. Irrespective of that, her mental dependence on Rivera became increasingly evident. In her diary she wrote:

"Diego:
Nothing compares to your hands,
nothing like the green-gold of your
eyes. My body is filled
with you for days and days. You are
the mirror of the night. The violent
flash of lightning. The
dampness of the earth.
The hollow of your armpits is my
shelter. My fingers touch
your blood. All my joy
is to feel life
spring from your flower-fountain
that keeps mine
to fill all the paths of my
nerves which are yours."

She still needed Rivera, fought for his love, demanded his affection. It was a severe blow for her that he not only continued his relationship with the dancer Emma Hurtado (whom he would marry after Kahlo's death), but also maintained a romantic attachment to the actress María Félix, even proposing marriage to her. Kahlo was aghast!

However, there was no second divorce because María Félix rejected Rivera's proposal and ended the relationship.

We read in Kahlo's psychological assessment: "Rivera's request for a second divorce [...] meant for Kahlo the end of her primary source of support. [...] The extent of Kahlo's dependence becomes clear in the severe despair with which she reacted to these two relationships [with Hurtado and Félix]. In order to underpin her unrealistically exaggerated evaluation of herself and so as to avoid the subconscious feelings of inadequacy, she was dependent on other people. [...] Kahlo was extraordinarily talented, intelligent and beautiful, but she had no inner access to any of these attributes. It is as if she owned a handful of pearls but was unable to wear them because she had no string to hold them together."

During the course of 1950 Kahlo spent ten months in hospital and underwent six operations on her spine. The bone implants repeatedly became inflamed and Kahlo had to take strong painkillers. From then onwards she needed constant assistance and was confined to a wheelchair.

Nonetheless she continued with her work as an artist. The phase of painting still lifes began. In 1953 one of her long-cherished wishes was fulfilled: the gallery of Lola Álvarez Bravo presented her first solo exhibition in Mexico City in April. Kahlo took part in the opening from a decorated canopied bed.

But in August she was to be re-admitted to hospital with the prospect of a major operation: her lower right leg was affected by gangrene

and would have to be amputated. On 2 July 1954 Frida Kahlo and Diego Rivera appeared together in public for the last time. They participated in a demonstration against the United States invasion of Guatemala. Four days later Frida Kahlo celebrated her 47th birthday with numerous guests. Just one week later, on the morning of 13 July, she died of a pulmonary embolism. Whether a large dose of tranquillisers also played a role in her death, remains unclear until today.

The Diary

For ten years—from 1944 until 1954—Frida Kahlo kept a diary, which was in fact much more than just a journal. It was also an artist book which reflected her thoughts and feelings in writing and pictures which often fuse to create an indissoluble unit. The first pages are written in the form of a "Stream of Consciousness". Associative chains of words permit conscious topics to appear without the narration of events in descriptive form or a temporal sequence. And her thoughts repeatedly focus on Rivera:

"He does not see the colour; he has the colour.
I make the form. He does not look at it.
He does not give the life that he has.
He has life.
His voice is warm and white.
He stayed without ever arriving."

This associative-poetical section is followed by letters which are directly addressed to Rivera and which reveal the unconditional bond to her lover: "I beg you for power, mindless power, and you give me beauty, your light and your warmth."
In the following sections of the diary independent texts alternate with letters to her adored lover which, at times, verge on self-abandonment: "Nobody will ever know how much I love Diego. I do not want anything to harm him. Nothing must disturb him or take his strength which he needs to live—to live the way he wants."

Between these passages, which are focused directly or indirectly on her all-consuming love, we repeatedly find humorous texts which she illustrates with drawings: "The hideous, primitive Oculosaurus, an ancient creature that dropped down dead in order to attract the attention of the scientists. It looked upwards and had no name. So we gave it one: the hideous Oculosaurus!"

The third set of subjects to which she turns repeatedly is the class struggle. After the assassination in 1940 of Leon Trotsky (with whom she had had a brief affair) by the devout Stalinist Ramón Mercader she turned once again with great enthusiasm to the man who had ordered the killing: the Soviet dictator Joseph Vissarionovich Stalin. "Stalin astounded the revolutionary world which is my world. Long live Stalin. Long live Malenkov!", she wrote in her diary in 1953. She expected Communism not only to bring about Paradise on Earth, but also to cure all those who were ill, including herself, as she expresses in the obscure picture *Marxism Will Give Health*

gota, sota, mota.
MIRTO, SEXO, FOTO,
LLAVE, SUAVE, BROTA
LICOR mano dura
AMOR silla firme
GRACIA VIVA
VIVA PLENA
LLENA SON...

SONRISA

TERNURA

to the Sick. As a whole the texts in the diary offer few surprises; they reflect all that we know about Frida Kahlo as an individual: her courage, her vulnerability, her destructive love for Diego Rivera and her steadfast, almost childlike belief in Communism and all its fine promises.

However, the full-page gouaches, watercolours and China-ink drawings which accompany these texts, often in mixed technique, do not really comply with our accustomed image of the artist. Here we find a blatant break with everything which Frida Kahlo had produced hitherto as regards both painting technique and style. The imagery loses the narrative elements; here no stories are told, there is no more folklore, nor does a pointed brush paint the symbolist "narrative pictures" neatly right down to the final varnish. Here explosions take place! These pictures are not "contemplative", do not invite us to look at and decipher them, but rather shout at the viewer. The forms explode, radiate an unexpected power and become entangled; they fight each other, and a suggestive effect unfolds. They seem almost uncannily modern, recalling graffiti and what we now call Abstract Expressionism. Kahlo makes no corrections: if she does not like the writing or part of the image, she scribbles over it and combines the scribblings into the composition.

In artist's language we would say: "these sheets have been spewed out by a genius!" Yes, they are homogeneous, painted in one go, with the assuredness of a sleepwalker. The break in style is by no means due to the intellectual and physical decline of their maker, as some writers suspect.

No, they are an act of liberation! They represent a magnificent artistic achievement which has hitherto not been acknowledged and which urgently requires scholarly study. And it is a legacy: Come and look! I was never able to free myself from my mental shackles and my physical suffering; only in my art was I able to achieve that!

Companions, friends and lovers

The widespread popularity of Frida Kahlo and Diego Rivera can be ascribed not so much to their artistic achievements as to their unconventional life together, their various affairs, and the "free love" which they practised to the bitter end, with all its wonderful moments and its torture. What they also shared were their revolutionary political views and their fundamental Marxist convictions, although Rivera's approach was distinctly pragmatic. It did not prevent him from painting frescoes for a top fee on behalf of "picture-perfect capitalists" such as Nelson Rockefeller and Edsel Ford.

In Kahlo's case the belief in the blessings of Communism acquired a decidedly pseudo-religious function, as the picture *Marxism will Give Health to the Sick* (1954) demonstrates. For her it was also of existential importance that she should repeatedly find people who could

satisfy her hunger for love and admiration. She needed nothing more urgently than affection and sympathy in order to be able to fight against the various limitations and threats which her physical and mental disabilities compelled her to face. So who were the people with whom she surrounded herself, who loved and worshipped her and with whom did she establish long-lasting relationships which often continued throughout her entire life?

Early love: Alejandro Gómez Arias 1922–1925

Frida Kahlo met Alejandro Gómez Arias in 1922 at the Escuela Nacional Preparatoria ("Prepa") in Mexico City. They fell in love and their fellow-students regarded them as inseparable. "She wanted to go to the United States with Alejandro, to change her life, leave the provincial world and live in San Francisco [...] and Alejandro remembered that for her, sex was an obvious way to enjoy life, simply a necessity of life."

After her serious accident in 1925, Kahlo simply could not understand why "Alex", as she called him with tender affection, did not visit her during her long stay in hospital. On 27 December 1925 she wrote to him: "Not for anything in the world can I stop speaking with you. I may no longer be your Novia [bride], but I shall always speak to you [...] because now, when you are leaving me, I love you more than ever." In spite of all Kahlo's attempts to save her relationship with Arias, they went their separate ways. After graduating from the "Prepa" he travelled through Europe, studied

law at the University of Mexico City and became a well-known and highly regarded journalist and lawyer.

The "paternal friend": Fernando Fernández 1925/26

In early 1925, Frida Kahlo began an apprenticeship in the printer's workshop of the graphic artist Fernando Fernández, a friend of her father's. He taught her how to draw, and she learnt about various artistic printing techniques there. He was very attentive and praised her artistic talent. "If we can believe Gómez Arias, this attentiveness made such a deep impression on Kahlo that a brief affair developed between Fernández and his student. "The girl [...] was now a modern young woman, full of the exuberant liveliness of the twenties and with little sense of conventional moral attitudes." The amorous adventure ended in September with Frida Kahlo's serious accident. According to her biographer Hayden Herrera, Kahlo had also embarked on a homosexual relationship during that same year with a librarian who worked in the Ministry of Culture. It has been proved that she told Gómez Arias of her sexual escapades, presumably hoping to arouse his jealousy, but she did not succeed in winning him back.

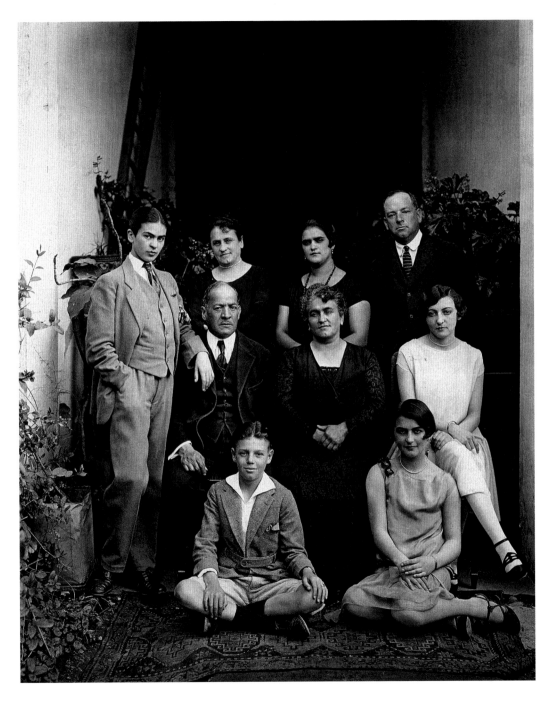

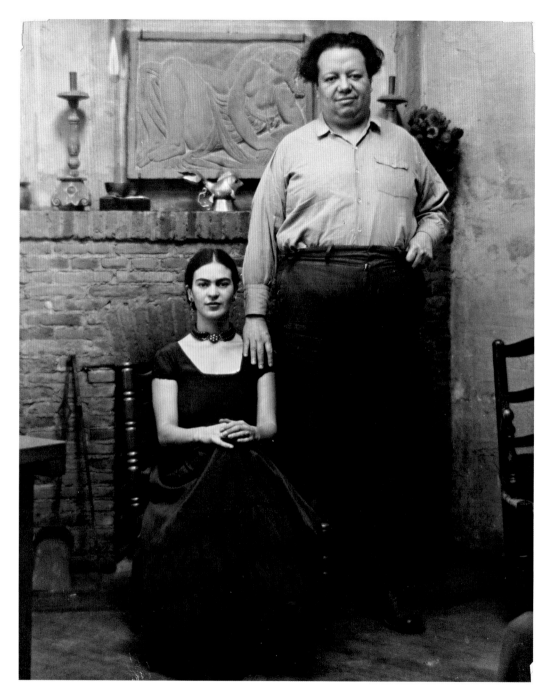

Lifelong addiction: Diego Rivera. First marriage 1929, divorce 1939, second marriage 1940

The involuntary end of her love affair with Alejandro Gómez Arias remained a traumatic experience for Kahlo. We can assume that the early, far-reaching experience of being left was to have a considerable effect on her later relationships, especially that to Diego Rivera. On the one hand she clung with all her strength, almost with an element of self-sacrifice, to this man. On the other, however, she also maintained a series of love affairs, no doubt to have something "of her own" enabling her to maintain her self-respect in the face of Rivera's numerous escapades. "In time Kahlo took lovers of both sexes in order to avoid feelings of emptiness. She imagined that Diego Rivera would fill this emptiness, but she was wrong: a commitment to another human being apart from himself was just not part of his repertoire."

"You will always be alive on the earth": the poet Carlos Pellicer 1926–1954

Carlos Pellicer was born into a middle-class family in Villahermosa in 1897. His father ran a pharmacy, and his mother had enjoyed a good cultural education and was very interested in art. Like Kahlo, Pellicer had attended the "Prepa" in Mexico City. In 1921 he founded the group "Solidarity with the Workers' Movement" together with Diego Rivera, José Clemente Orozco and Vicente Lombardo

Toledano. During this time he met Frida Kahlo. Later Pellicer became Professor for Lyric Poetry at the National University and took over the Department of Fine Arts as Director. He loved and admired Kahlo until her death. At her funeral he recited a sonnet which he had written for her: "You will always be alive on the earth / You will always be the heroic flower of successive dawns [...]."

The kindred spirit: Georgia O'Keeffe 1929–1933

Frida Kahlo met Georgia O'Keeffe and her partner, the photographer Alfred Stieglitz, in New York in 1929. Three years later O'Keeffe had a nervous breakdown and had to be treated in a clinic. On 1 March 1933 Kahlo wrote an affectionate letter to the painter: "Georgia, it was wonderful to hear your voice again. Every day since I called you and many times before, months ago, I wanted to write you a letter. I wrote you many, but every one seemed more stupid and empty and I tore them up. I can't write in English all that I would like to tell, especially to you. [...] Diego is good to me, and you can't imagine how happy he has been working on the frescoes here. I have been painting a little too, and that helped. I thought of you a lot and never forget your wonderful hands and the colour of your eyes. I will see you soon. I am sure that in New York I will be much happier. If you are still in the hospital when I come back, I will bring you flowers, but it is so difficult to find the ones I would like for you. I would be so happy

Carlos Pellicer

if you could write me even two words. I like you very much, Georgia. Frida."

Lucienne Bloch (page 64) remembered one morning in Detroit, when they were sitting together at breakfast and Rivera suddenly astonished her by pointing towards Kahlo and saying: "You know that she is homosexual, don't you? [...] Frida simply laughed and Diego continued to tell her how his wife had flirted with the artist Georgia O'Keeffe when they were in New York."

"My adorable Nick ...":
Nickolas Muray 1931–1939

Nickolas Muray was born as Miklós Mandl in Szeged in southern Hungary in 1892. At the age of 17, after completing an apprenticeship in a photo studio, he moved to Munich and later to Berlin, where he worked as a lithographer at Ullstein. Soon after reaching adulthood, he emigrated to the United States. There he became one of the best photographers and achieved fame above all for his portraits of prominent personalities from art, sport and politics. He was also a successful sportsman himself and participated in the Olympic Games twice in the discipline of fencing. Kahlo and Muray met in Mexico in 1931 and launched into a passionate affair, later meeting sporadically and remaining correspondents for many years. On 27 February 1939, Kahlo wrote from Paris to Nikolas Muray in New York:

"My adorable Nick, this morning after so many days of waiting your letter arrived. I felt so happy that before starting to read it I began to cry. My child, I really shouldn't complain about anything that happens to me in life as long as you love

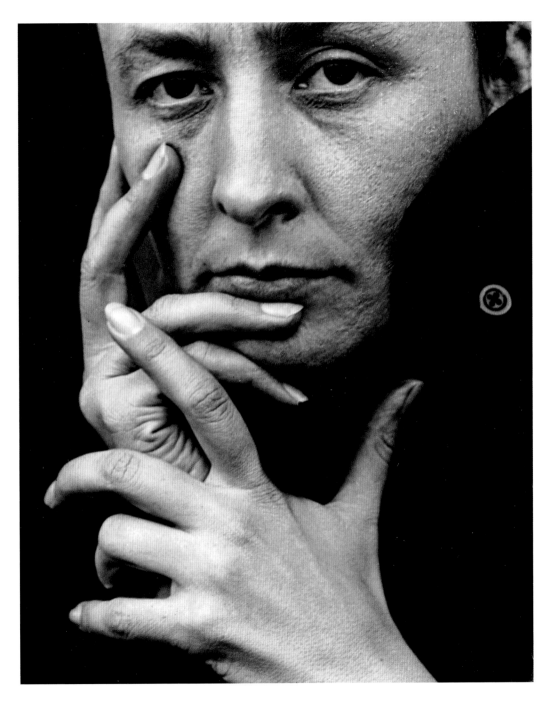

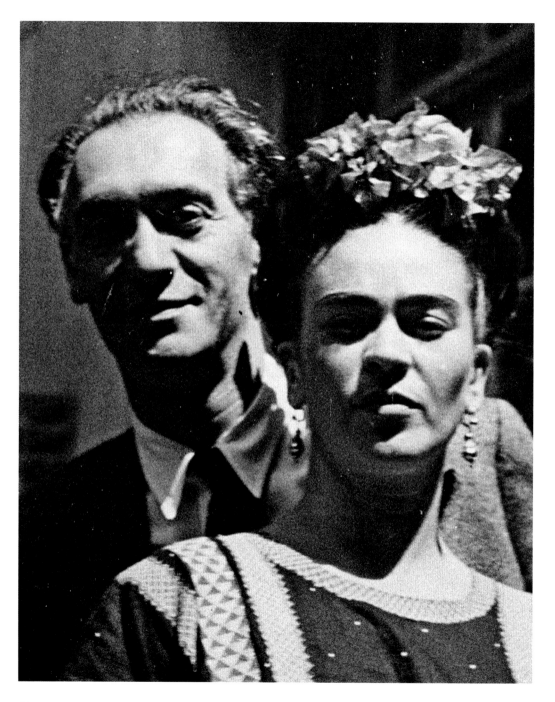

me, and I love you. It is so real and beautiful, that makes me forget all pains and troubles, makes me forget even distances. Your words made me feel so close to you that I can feel [you] near me—your eyes—your hands—your lips. I can hear your voice and your laugh. That laugh so clear and honest that only you have. I am just counting the days to go back. A month more! And we shall be together again!"

"Nick probably hoped secretly that one day Frida would have had enough of Diego's gratuitous unkindness and would commit herself entirely to her love for him. However, he had discounted one aspect: Frida's masochism." On 16 May 1939 Kahlo received a letter from Muray, in which he explained why a permanent relationship with her would not be possible. Although they remained in contact by letter, their passionate relationship was over.

"Dear, dear Frida, I should have written to you a long time ago. It is a complicated world that we live in, you and I. [...] Of the three of us [Frida Kahlo, Diego Rivera and Nick Muray], for you really there were always only two who were important, and I have felt that for a long time. And your tears when you heard his voice betrayed it to me too. The one of us that I am will always be grateful to you for the happiness that one half of your being so generously gave me. My dearest Frida—like you, I have always longed infinitely for true affection. When you left it was clear to me that it was all over. Your instinct led you wisely. You did the right thing, because I could not transplant Mexico to New York for you, and I have now understood how essential it all is for you. [...] Strangely, it has changed nothing about my affection for you, and nothing will change that. [...] I should like to know everything that you think it is right for me to know. Sincerely, Nick."

"Curtain up!": Paulette Goddard, Tina Modotti, Dolores del Río, Chavela Vargas, María Félix, Pita Amor and Josephine Baker

Frida Kahlo and Diego Rivera surrounded themselves with an illustrious social circle of intellectuals, left-wing politicians and artists. But they also maintained good relationships with famous actresses and stage stars of their time. Many of these women succumbed to Rivera's advances, sometimes simply as a brief dalliance, but often as a more or less casual relationship that could last for many years.

Once Kahlo had recognised that nothing in the world would dissuade Rivera from pursuing these amorous liaisons, she not only increased her own sexual activities with other partners, but also attempted with greater or lesser success to establish erotic, or at least friendly relationships with her husband's lovers.

She was successful in the case of Paulette Goddard. The American diva and Diego Rivera were involved in a passionate affair in 1939/40. In one of his murals the artist depicted himself between Frida Kahlo and Paulette Goddard. While he lovingly holds Goddard's hands, he has turned his back on Kahlo. After Kahlo and Rivera

had remarried on 8 December 1940 the two women became increasingly good friends and were certainly very close, although there is no definite proof of a sexual relationship between them.

The relationship between the actress and photographer Tina Modotti and Kahlo and Rivera was very similar. Modotti was born in 1896 in Udine in Italy and emigrated to the United States at the age of 17. She played in several films before turning her attention entirely to photography. She met the photographer Edward Weston in 1921 and became his lover and model, and it was through Weston that she came into contact with Diego Rivera and Frida Kahlo in 1923. She found them both fascinating, as regards not only their art but also the unconventional lifestyle they led. The triangular relationship Modotti-Rivera-Kahlo became increasingly determined by erotic desire, but the trio was even more closely linked by their ardent faith that the world would be saved by Communism.

Marlene Dietrich described Dolores del Río as the most beautiful woman in Hollywood. Diego Rivera regarded her as "the most beautiful woman in the West, East, North and South. I am in love with her like 40 million other Mexicans and 120 million Americans, and they cannot all be wrong." Frida Kahlo gave her the little painting *Girl With Death Mask I* (page 86), which may seem strange and could be a sign of an underlying aggression towards the film star on the part of the artist. Dolores del Río, however, saw in the figure with the death mask the child that Kahlo was unable to have. She had spoken with Kahlo

about this sad subject on several occasions, which seems rather to indicate that the relationship between the two women was characterised by intimacy and trust.

"Chavela Vargas woke up beside a great many women." That is not hard to believe. A beautiful woman who took what she pleased—that was her role. And perhaps men did not hold it against her, because she behaved in such a macho-like way in doing so. Not even those whose wives she seduced. "There is no eternal love", she said in a documentary film about her life and work in 2017, "Do not rely on love to govern your life, because it will not solve any problems." Vargas was lesbian, an artist and consumed by a longing for freedom, a longing which was additionally fuelled by parties and alcohol.

During an impromptu performance on a square in Mexico City she met Diego Rivera and Frida Kahlo and was invited by the two of them to their house. The visit became a sojourn that lasted for several weeks. "I know all Frida and Diego's secrets, but I would never reveal them. We were happy, we lived from day to day without a cent; sometimes we had nothing to eat, but we would still almost die of laughing", Vargas explained in an interview.

María Félix, born in 1914, was a match for Chavela Vargas in every respect. She was one of the most popular actresses in Mexico during the 1940s and played in the films of famous directors such as Luis Buñuel and Jean Renoir. She was married five times, amongst others with the singer Agustín Lara who composed the song

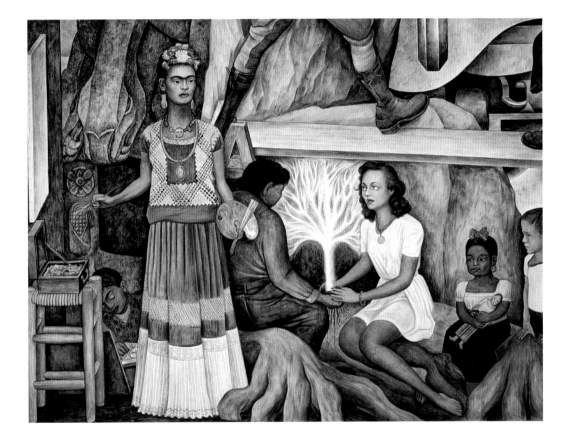

Paulette Goddard (in white) on a mural by Diego Rivera in San Francisco, 1940

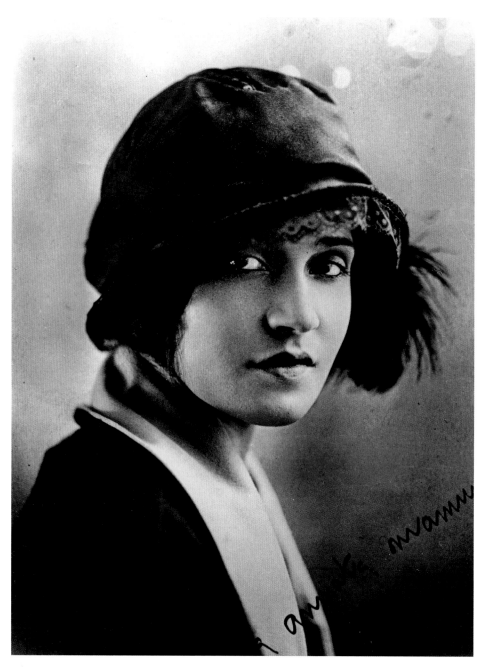

Tina Modotti, 1921

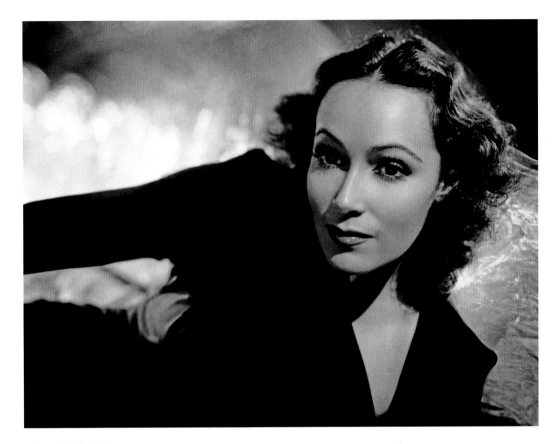

Dolores del Río, 1938

"María Bonita" for her; it became a popular hit not only in Mexico. In 1948 Diego Rivera wanted to marry María Félix, "after he had painted her during forty sittings [...] to which no one else was admitted. Thereafter he painted the woman poet Pita Amor."

"Three major newspapers published the 'news' that Félix had accepted Rivera's proposal of marriage on condition that she could bring her twenty-two-year-old friend into the marriage as a third partner." The girl had previously worked as Frida Kahlo's nurse. In spite of these confusing arrangements Kahlo remained true to her position and, for her part, made an effort with the rivals. "In fact, Frida Kahlo, María Félix and Pita Amor, with whom Rivera is also said to have had an affair, were close friends. The photo of Pita Amor was fixed to the head of Frida Kahlo's bed and María Félix's name was the first on the list which adorned Kahlo's bedroom in Coyoacán".

Josephine Baker was born as Freda Josephine McDonald into humble circumstances in St. Louis, Missouri on 3 June 1906. Even in her youth she developed an outstanding talent as a singer and

The young Chavela Vargas

dancer, went to Europe and had a successful career in Paris, especially through her appearances in the *Revue nègre*. She joined the French secret service in the 1930s and was involved in the Résistance during the Second World War. She was consequently admitted to the Legion of Honour after the war ended. Frida Kahlo met Baker during her sojourn in Paris in 1939, when she was divorced from Diego Rivera. The two women experienced an intensive period together and subsequently remained in contact. As far as we are aware, Baker was Kahlo's only lover who had nothing to do with Rivera.

Lucienne Bloch 1931–1954

Lucienne Bloch came from a Swiss family of artists; her father was the composer and photographer Ernest Bloch. At the age of 14 she attended the École nationale supérieure des Beaux-Arts in Paris, where Antoine Bourdelle and André Lhote were her most important teachers. In 1917 the family emigrated to the United States. There, too, she was able to continue her career, designing glass sculptures and teaching at the Taliesin East School of Architecture in Wisconsin.

María Félix in the film *La diosa arrodillada*
(The Kneeling Goddess), 1947

Josephine Baker with her pet cheetah Chiquita, 1920s

She became Diego Rivera's assistant in 1931. After a meal during which Bloch had held an animated conversation with Rivera, Kahlo, who suspected a new rival, is said to have hissed at her: "I cannot stand you!" But before long Bloch had become one of Frida Kahlo's closest friends. When Kahlo's mother became gravely ill in 1932, she travelled with her to Mexico, and when Kahlo suffered a miscarriage in Detroit, she remained constantly at her side. Frida lost a great deal of blood, and, Bloch noted: "She looked tiny, like a twelve-year-old, and her plaits were soaked with tears." She quietly and calmly

supported her friend in the disputes between Kahlo and Rivera, which were often very heated.

"Charming, exuberant, unusually handsome ...": Isamu Noguchi 1935

Isamu Noguchi embodied in his life and works the links between Far Eastern and Western-American traditions. His father was the Japanese poet Yone Noguchi, his mother, the American writer Leonie Gilmour. He studied art in the United States, then worked as Constantin Brâncuși's assistant in Paris, and continued his training as an illustrator and

Lucienne Bloch, 1938

Isamu Noguchi, 1943

designer in China and Japan. His oeuvre includes numerous sculptures, design objects and drafts for lamps and furniture which continue to be produced and sold successfully to this day. He was also successful as a stage designer and landscape gardener and designer.

Noguchi and Kahlo met in 1935 in Mexico City, while Frida Kahlo was suffering due to the affair between her sister Cristina and Diego Rivera, and her suspicion had given way to the certain knowledge that Rivera would never be able to live in a monogamous relationship. Her picture

A Few Little Cuts (page 32) tells memorably of the affair. Because of her current situation she spontaneously accepted the advances of the young and attractive artist. But this liaison was destined to be of short duration too. After his scholarship expired Noguchi returned to the United States. It is not clear whether Rivera's repeated threat to kill his young rival precipitated his departure.

The Great Revolution:
Leon Trotsky 1937

Lev Davidovich Bronstein, born into a Jewish family in the Ukraine, had called himself Leon Trotsky since 1909, probably because Anti-Semitism was also widespread amongst the Bolsheviks. In Communist propaganda "International Jewishness" was often referred to in the same breath as "American Imperialism".

The successful "War Commissar" was regarded as Lenin's most important associate. He was the founder and organiser of the Red Army. After Lenin's death in 1924 Trotsky lost the heated dispute with Stalin about the right path for Communism and was forced to flee into exile. He and his wife had been on the run from his powerful adversary for nine years when, on 9 January 1937, they reached the port of Tampico in Mexico on board a tanker. Rivera and other left-wing artists and intellectuals had campaigned energetically to permit the outcast to be granted asylum. Frida Kahlo and Diego Rivera took the Trotskys in and put them up in the "Blue House". The exiled couple aroused much interest; the daily newspapers reported at length and the American weekly magazine *Time* stated on 25 January 1938, among other details, that the guest was "looked after and taken care of by his awe-struck dark-eyed hostess". That was not all. Although Trotsky was twenty years older than his hostess and conversations with her could only take place in English, the two rapidly became close. "Kahlo accepted Trotsky's advances [also] because she wanted to take revenge on Rivera, who had embarked upon a sexual relationship with her sister [Cristina] while she was in hospital", which hurt her deeply. But here, too, Frida Kahlo was no match for Diego Rivera, "who knew how much he could hurt her simply by withdrawing—a game of which he was a true master. She was too dependent on him to fight him openly, and she was too afraid of being abandoned. He on the other hand took enormous pleasure in hurting her, and so he could not let her leave either."

He made Frida Kahlo famous in
New York: Julien Levy 1938

"To my great surprise I received a letter from Julien Levy: he had heard about my pictures and was interested in exhibiting them in his gallery", wrote Frida Kahlo to her friend Lucienne Bloch in the summer of 1938. Levy ran a small but exclusive gallery for modern art in Manhattan and represented above all the French Surrealists.

Soon after Kahlo's arrival in New York they fell in love. "Levy, who succumbed to Frida's charms like many others at that time, recalled that she behaved with abandonment and in a completely free manner in her relationships with the other sex." She also told him quite openly of her complicated relationship with Rivera, and Levy soon realised how strong the ties between his new lover and her husband and artistic mentor were. And so this amorous adventure also ended as quickly as it had begun.

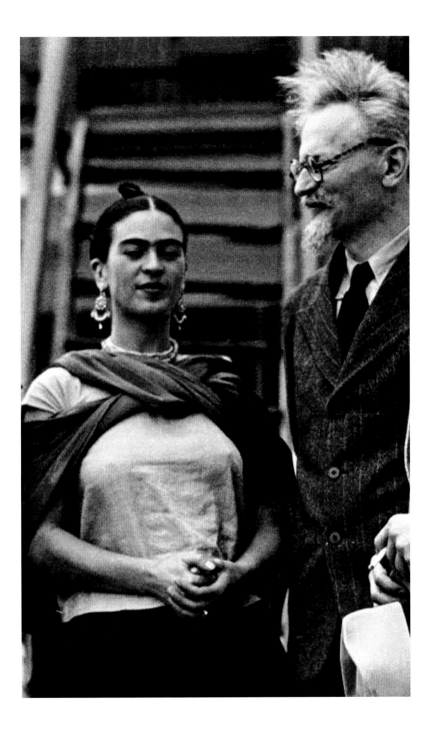

Jacqueline Lamba 1938

Jacqueline Lamba was the second wife of the French poet André Breton. The couple met Diego Rivera and his wife Frida Kahlo during Breton's lecture tour through Mexico. Lamba and her husband lived in the "Blue House" in Coyoacán for several weeks and the relationship which brought the two women together at this time was as close as it was intimate. In 1939 Lamba wrote Kahlo an affectionate letter from Paris: "Since you wrote to me on that clear day so long ago, I wanted to explain to you that I cannot leave those days behind and return punctually to the other time. I have not forgotten you. [...] Today I wish that my sun could touch you."

"You will fall in love with my wife": Heinz Berggruen 1939

On the fiftieth anniversary of Frida Kahlo's death, Heinz Berggruen wrote in the *Frankfurter Allgemeine Zeitung* about his relationship with Frida Kahlo: "Her husband, Diego Rivera, the great Mexican painter of frescoes, [...] took me to meet her. At the entrance to the hospital in which Frida lay, he stopped for a moment, looked at me with his big Picasso eyes and said in French—he spoke no English and I not a word of Spanish: [...] 'You are going to meet my wife, and you will fall in love with her.' He repeatedly confused the intimate and polite forms of address, but I was used to that.

So we entered the room in which Frida lay, and what happened was exactly as Diego had predicted. I have often written about my relationship to Frida. About our spontaneous, intensive love for each other, about my 'flight' with her to New York, about our wild life in Manhattan. At that time Frida was not yet a legend and far away. She was the unknown daughter of a Jewish-German immigrant—hence her name, Frida—and an [American] Indian. [...]

During the entire time that we were together I never saw any of her pictures; I hardly knew that she painted, and I had no premonition of the astonishing cult figure into which she developed, more than virtually any other artist of our age. To me she was simply a young, unusually attractive Mexican woman possessed by a passionate joie-de-vivre. After one long month we separated; she returned to her Diego and I to my family and my work. It was the end of an exciting dream.

[...] When Frida died fifty years ago, after unspeakable pain, I knew that I had lost a wonderful friend. Frida Kahlo the individual had been transformed in the meantime into a legendary fairy-tale figure. In my memory she remained the diminutive, delightfully dressed Mexican woman who radiated an adorable charm, with whom I had once strolled the streets of Manhattan."

André Breton, Diego Rivera, Leon Trotsky and Jacqueline Lamba, 1938

A late "friend for life": Emmy Lou Packard

The Packard family had moved to Mexico in 1927. Emmy, aged 13, took painting and drawing lessons with Frida Kahlo. When she was expecting a child by the student Burton Cairns, the two of them fled to California. In 1936 Emmy Lou Packard completed her university course and changed to the San Francisco Art Institute in order to study sculpture and mural painting. After her husband was killed in an accident at a young age, she returned to Mexico in 1939 and worked as Diego Rivera's assistant. Frida Kahlo and Emmy Lou Packard became friends, after Kahlo had come to the conclusion that Packard did not represent a danger as far as Rivera was concerned. When Frida Kahlo's father died in 1941, Kahlo was plunged into a profound crisis, and during this time Emmy Lou Packard provided her with valuable support.

Heinz Berggruen as an American soldier, 1943

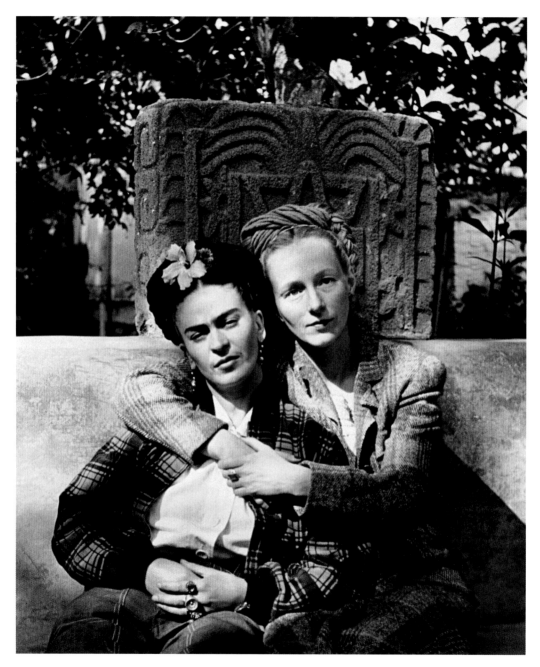

Frida Kahlo with Emmy Lou Packard, 1941

José Bartoli

Kahlo's last great love: José Bartoli 1943–1946

The Catalan artist José Bartoli was born in Barcelona in 1910. During the Spanish Civil War he fought on the side of the Republicans. He was taken prisoner but was able to escape during transportation and made his way to France. He arrived in Mexico after various adventures in 1943 and met Diego Rivera and Frida Kahlo. Kahlo and Bartoli embarked on a passionate love affair which they succeeded in keeping secret for many years.

When Bartoli died in 1995, his family found a chest with his souvenirs of Frida Kahlo: hair ribbons, scarves, letters, sketches, and a little oval medallion measuring about 5 by 4 centimetres. On the back of the miniature painted in 1946, Kahlo had written in red: "para bartoli con amor—mara". "Mara" was the name with which Frida had signed all her love letters to Bartoli "as a precautionary measure".

The caring one: Olga Campos 1947–1954

Olga Campos and Frida Kahlo met at a post-birthday celebration for Diego Rivera on 8 May 1947. A friend, Jaime Barrios, knew some of Rivera's assistants and encouraged Campos to attend the party with him. "I agreed without hesitation. I was dying to meet the famous artist and his equally famous wife, the painter Frida Kahlo. [...] I was dazzled by her appearance from the first moment. Frida looked beautiful and was chatting with Diego. She looked like a queen, her head crowned with coloured ribbons and flowers which she wore woven into her plaited hair. She was wearing large golden earrings, and her shoulders were covered by a cape with velvet trimmings."

A close friendship developed from this first encounter. Campos remained loyal to Kahlo at all times, even when she could not approve of many aspects of her lifestyle out of concern for her friend's health. In 1950 she conducted a lengthy interview with the artist. In fact this resulted in a life story leading to a psychological assessment which Campos drew up together with the psychologist James B. Harris. These texts are of prime importance for an understanding of Frida Kahlo as an individual, as well as the art which she produced.

During Frida Kahlo's periods in hospital, Campos remained at Kahlo's side and cared for her. By 1951 she had undergone a total of thirty-two surgical operations on her spine and right leg. Frida Kahlo's revealing "drawings expressing emotions" were created in 1950 at the suggestion of Olga Campos. After Kahlo's death she was one of the first mourners and recalled this moment: "It was dreadful for me. When I arrived, Frida was still quite warm. I kissed her and I thought for a moment that she got goose pimples as I did so; I started to shout: 'She is alive, she is alive!' But of course she had already been dead for a while."

Portrait Olga Campos, 1949

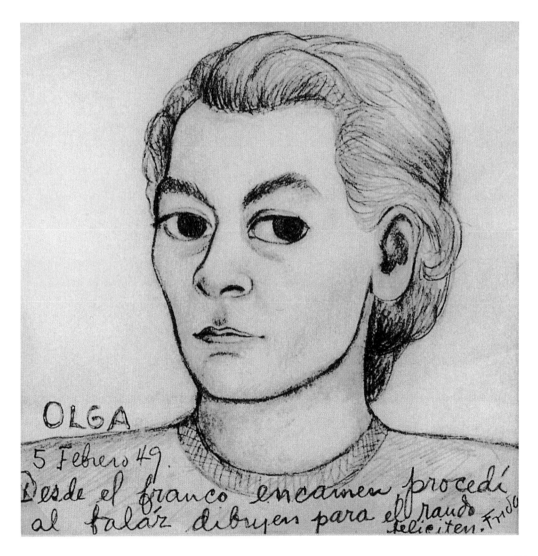

OLGA

5 Febrero 49.

Desde el franco encarnen procedí
al falaz dibujen para el rando
feliciten. Frida

WORKS

Self-Portrait with Velvet Dress, 1926

Oil on canvas
80 × 60 cm
Private collection

This picture portrays an idealised reality. Kahlo painted it about one year after her serious accident which had confined her to her bed for almost a year and which condemned her to a life marked by pain and illness. Nothing—nothing in the slightest of all that can be detected here. Kahlo has "painted over" her suffering, portraying herself as a beautiful young woman in a velvet dress: a cross between a Renaissance princess and an Art Nouveau lady. The structure of the picture, the detailed execution of the painting and the fine materiality of the clothing refer back to the courtly portraits of the sixteenth century. The position of the overlarge hand and the excessively long neck evoke the portraits of Viennese ladies around 1900. Frida Kahlo looks earnestly and determinedly at the viewer.

We should not assume that Frida Kahlo chose these references consciously. At the time she was a nineteen-year-old schoolgirl who was still attending the Escuela Nacional Preparatoria in Mexico City, the "Prepa". There were reproductions of famous paintings on view in the photo studio of her art-loving father, however, and she received a sound art education at school. She wanted to paint herself as a "fine lady", and that is precisely what she has done here—just as she would later paint herself as a Mater dolorosa, as a child, a Tehuana bride or a little stag. Throughout her entire life she would paint her state of mind, her hopes and her sufferings and repeatedly find new metaphors for them. Pictures can hardly get more honest than this!

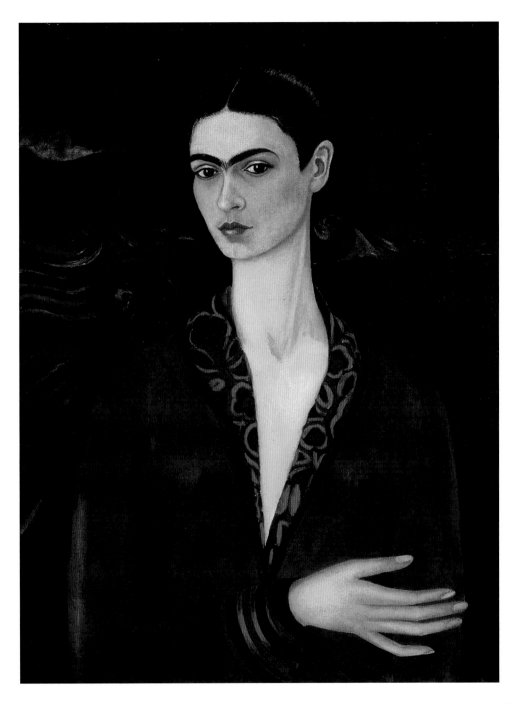

My Dress Hangs There or New York, 1933

Oil and collage on hardboard
46 × 50 cm
Estate of Dr. Leo Eloesser

Kahlo began the picture *My Dress Hangs There* or *New York* while she was still
in Detroit, and then completed it in Mexico. An arrangement of famous buildings
in New York provides the backdrop, and on the left is an enormous poster of the
Hollywood diva Mae West, whom Diego Rivera idolised. The artist has built up the
foreground in a strictly symmetrical manner. Her Mexican dress hangs there in the
centre of the picture, between two hovering fragments of pillars surmounted by a
toilet bowl and a golfing trophy. The artist proclaims in this way to her audience:
"It is only my empty shell that is hanging here in New York; my innermost soul has
remained in Mexico." The two pillars stand symbolically for Rivera (the pillar with the
toilet bowl) and Kahlo (the slender pillar with the trophy). To the right and left of
the pillars a burning house and an overflowing dustbin can be seen, symbols for the
hard life in the United States. In the lower part of the picture are collaged photos
showing ant-like people marching.
We can sense in the painting that Frida Kahlo's time in Paris and her contacts
with Surrealism were not without consequences. During the 1930s the artist used
Surrealist design principles with increasing frequency. She painted the objects in
her pictures in a painstakingly realistic style but put them together in a "surreal"
fashion, that is, in an unrealistic way, in order to express her feelings and thoughts.
When considered this way, *My Dress Hangs There* or *New York* is anything but the
artist's declaration of love for the United States.

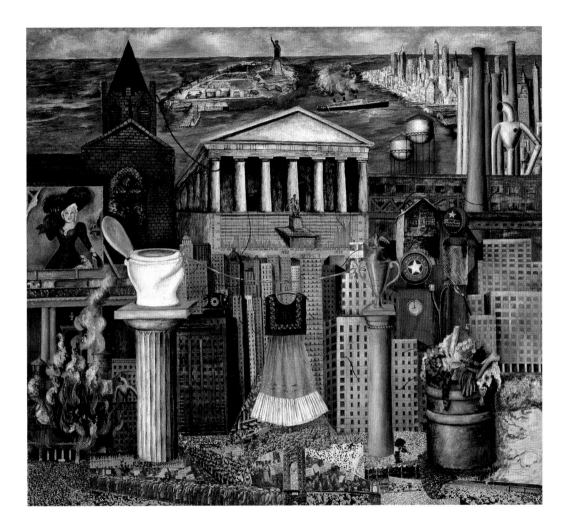

Memory or The Heart, 1937

Oil on metal
40 × 28 cm
Private collection

In December 1933 Rivera and Kahlo returned to Mexico from the United States, after which Kahlo's health deteriorated dramatically. She suffered from repeated miscarriages and had to spend time in hospital.

This picture, created four years after *My Dress Hangs There* or *New York*, includes many of the props used in the earlier picture, while none of the people in the picture is in one piece. The artist is standing on a beach at the seaside. Her left foot has been bandaged following the amputation of her toes. There is a large hole in her breast, which has been pierced by a metal rod on which two little cherubs are swinging wildly from both ends. To her right and left hang her school dress and her traditional Mexican costume as signs of past eras. An arm is growing out of each dress, while the sleeves of Frida Kahlo's jacket are empty. She has no arms and is condemned to inaction. Tears pour down her impassive face. A silent cry, suffering on suffering; she is complete numbed. As if all that were not enough, Kahlo's heart has been ripped from her body and lies beside her in the sand.

What had happened? While Kahlo lay in hospital, vainly fighting to save her child and her foot, Diego Rivera and Frida Kahlo's younger sister Cristina, a lone mother of two children, had embarked on a sexual relationship. Kahlo was stunned and in despair. She separated from Rivera—we are tempted to say: "Unfortunately not for ever!"

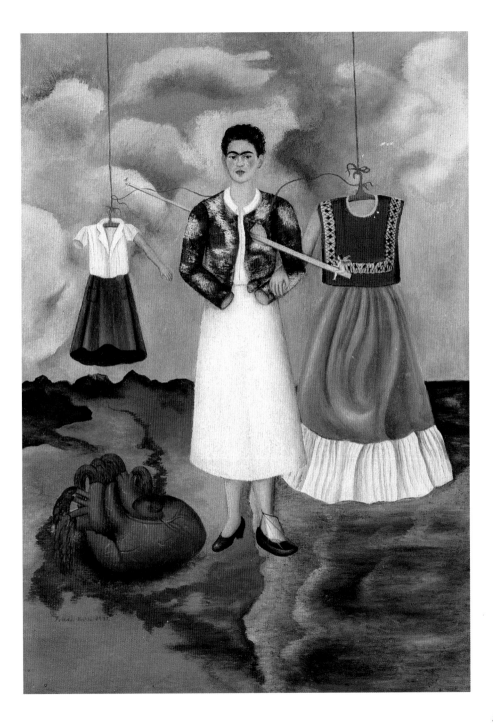

Self-Portrait Dedicated to Leon Trotsky or Between the Curtains, 1937

Oil on hardboard
87 × 70 cm
National Museum of Women in the Arts, Washington D.C.

In Frida Kahlo's handwriting, clearly written for all to read, the note proclaims:
"I dedicate this picture to Leon Trotsky on 7 November 1937 with all my love. Frida
Kahlo. In San Ángel, Mexico." She steps onto the stage like an actress, with the sole
purpose of announcing this message. She appears impeccably groomed, with flowers
in her hair and holding a bunch of flowers. He face is smooth and well cared-for,
her clothing almost courtly. No trace of suffering, no blood, no despair. The picture
was created in one of the brief periods in Kahlo's life during which she felt strong
and well. Nonetheless she was not happy, for at this time the constant "battle of the
sexes" with Rivera had reached one of its high points.
Frida Kahlo was unable to forgive Rivera for his affair with her sister; now she had a
chance for revenge. How could she have hurt her partner, an ardent Communist, more
deeply than by deceiving him with the great revolutionary leader, whom Rivera still
revered at this point as a hero of the Communist movement and a distinguished role
model? She made use of all her seductive powers in order to win over Leon Trotsky,
and in this she was successful. But Trotsky withdrew from the artist surprisingly
quickly. The politician wrote to his wife on 15 July 1937:
"I love you so much, Nata, my only, eternal, faithful, beloved one, who has to endure
so much from me." The couple was not able to enjoy this new-found harmony for very
long: three years later, on 21 August 1940, Trotsky died in Mexico City following an
assassination attempt that had been ordered by Stalin. Rivera and Kahlo were initially
suspected of having collaborated with the assassin, but the charge was dropped.
However, the killing of Trotsky did not deter Kahlo and Rivera from rejoining the
Mexican Communist Party, which was influenced by Stalinism; nor did it deter Frida
Kahlo from dedicating a memorial page in her diary to "Engels, Marx, Lenin, Stalin and
Mao". In 1954, the year in which she died, she even painted two portraits of Stalin as
well as the dubious, pseudo-religious picture *Marxism will Give Health to the Sick*.

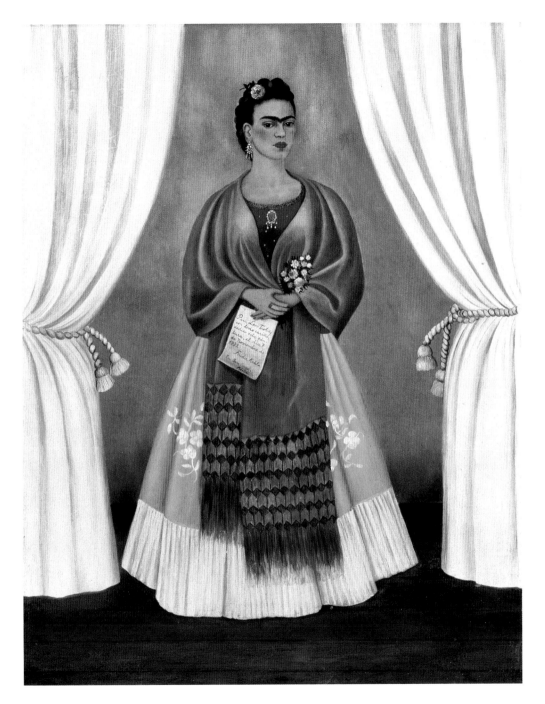

Girl with Death Mask I, 1938

Oil on metal
20 × 15 cm
Private collection

Death was a constant companion for Frida Kahlo as a result of the severe illnesses and disabilities which repeatedly resulted in life-threatening situations for her. She spoke about them in 1950 in an interview with Olga Campos:
"I would not want to die as a heroine or a coward. I think very often of death, too often. I despaired so much, I wanted to die. In 1935 I thought of suicide, and again a year ago. The second time, I attempted it. I would recommend barbiturates, in order to fall asleep.
There is a dialectic relationship between love and death: they are opposites. I don't believe in a life after death. It distresses me to see a dead body. I don't know what I would do if someone told me I had just one more hour to live. I imagine that I would think of Diego as I lay dying. The death of a beloved person is the thing that frightens me most. The death that affects me most is the slow death of a young person—any person."

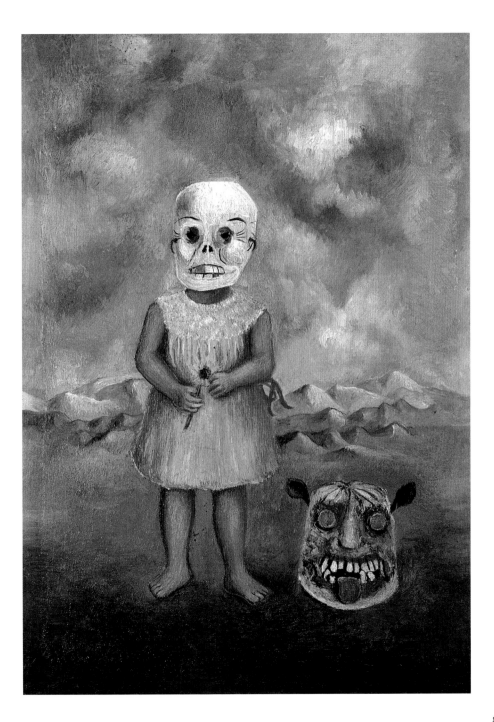

What I Saw in the Water or What the Water Gave Me, 1938

Oil on canvas
91 × 70.5 cm
Private collection

This picture shows clearly the extent to which Frida Kahlo was influenced by Surrealism. Nonetheless, the pictorial inventions of the French painters and those of the Mexican artist are worlds apart. Surrealists aimed to create realities that had not previously been seen, to escape from the constraints of logic and to question subversively everything bourgeois. In 1924 André Breton wrote in his first *Surrealist Manifesto*: "Surrealism is based on the belief in the superior reality of certain forms of previously neglected associations, in the omnipotence of dream, in the disinterested play of thought. It tends to ruin, once and for all, all other psychic mechanisms and to substitute itself for them in solving all the principal problems of life." All of that was completely alien to Kahlo's way of thinking. Her concern was to find images for her "actual" situation in life, to represent her fears, to show her tortured body, to shout out the misery of her overwhelming, unhappy love. Frida Kahlo is being strangled by a rope that has been stretched across two rocky peaks. The rope has been wound several times around her neck and ends in the hand of a man lying in wait on the beach who is unrecognisable because of his metal mask. Beside her floats her Mexican traditional costume, which we recognise from her painting *My Dress Hangs There* or *New York* from 1933 and elsewhere (page 81). On the right-hand side we can see her parents and the two nude women whom she would paint in a separate picture a year later (*Two Nudes in the Wood* or *The Earth* or *My Nurse and I* , 1939, page 94). Frida Kahlo did not want to advance into the metaphysical, and she was interested neither in literary references nor in art theories. She hauntingly shows her own state of mind and her daily struggle to survive.

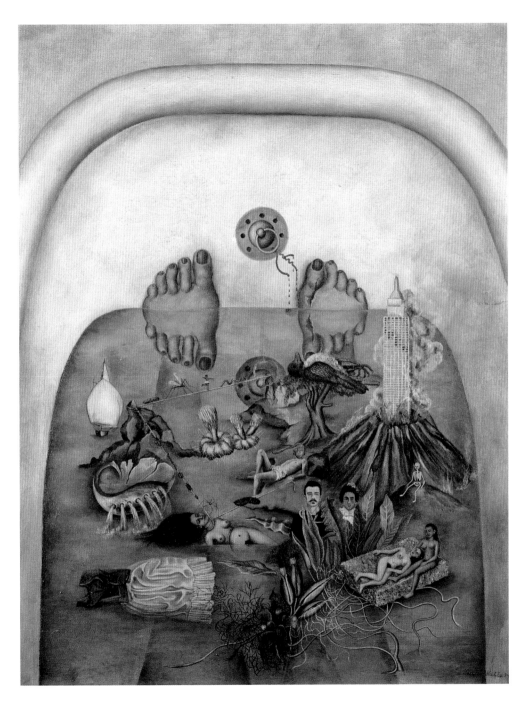

Self-Portrait with Monkey, 1938

Oil on hardboard
40.5 × 30.5 cm
Albright-Knox Art Gallery, Buffalo, New York

In her house in Coyoacán, Frida Kahlo had not only a little Mexican itzcuintli dog and some parrots, but also the tame monkey Fuang-Chang, which can be seen on several of her self-portraits.

In this picture created in 1938 the monkey is not really shown as an animal, but as a comrade and her equal. The creature lovingly places its arm around its mistress's neck in the way that only a good friend would do. Fuang-Chang is focussing on the same spot outside the picture as Kahlo : both are staring penetratingly and intensively at the viewer. You cannot hide from this gaze; they can "see through" you in the true sense of the word! Frida's bone necklace can be seen as a vanitas symbol, and the background shows the dense green wall of the jungle, which is barely accessible for human beings and yet all life comes from it.

Of course, Frida Kahlo was familiar with the powers and skill with which monkeys are endowed in the imagination of the native population. They are attributed with the ability to feel emotions such as love. For the Indians, the monkey is a symbol of strong and unbridled sexuality. Monkeys are playful and inquisitive, but they can also act aggressively if they feel they are being pressured or threatened. The monkey behaves almost like the rest of us, and that is precisely how Frida Kahlo has painted her companion!

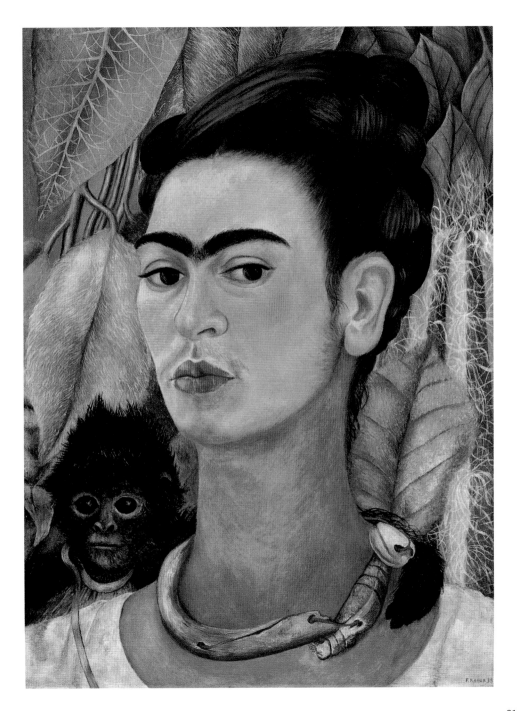

The Suicide of Dorothy Hale, 1939

Oil on hardboard
60.5 × 48.5 cm
Phoenix Art Museum, Phoenix, Arizona

In this mercilessly brutal picture, Frida Kahlo "tells" of the suicide of the actress Dorothy Hale, who was very well-known at the time. In order to rule out any misunderstanding, she added three lines of text to the picture: "In New York City on the 21st of October 1938, at 6:00 in the morning, Dorothy Hale committed suicide by throwing herself from a very high window in the Hampshire House. In her memory [...], this retable was executed by Frida Kahlo."
We see the protagonist three times. As a tiny figure she jumps feet first out of the window; the second time we see her falling head first, partially obscured by wildly swirling clouds of mist; and on the third occasion she is lying dead on the ground. She is wearing a black velvet ball gown, and in her décolleté is a bouquet of yellow roses that, ironically enough, Isamu Noguchi—one of Frida Kahlo's lovers (page 65)—had sent her. She appears at first glance to be completely uninjured as she lies there, and yet blood is pouring from her nose, mouth and ears. Nonetheless, she is gazing at the viewer questioningly with her eyes wide open.
A friend of the dead woman, Clare Boothe Luce, had commissioned Kahlo to paint a retable in honour of the deceased, which she intended to give to Hale's mother. "I shall never forget the shock which went through my entire body as I unpacked the picture. I literally felt ill." And so the picture remained in the possession of the donor; the dead woman's mother was never confronted with it. It later found its way into the possession of the Phoenix Art Museum, which is where it still is today.

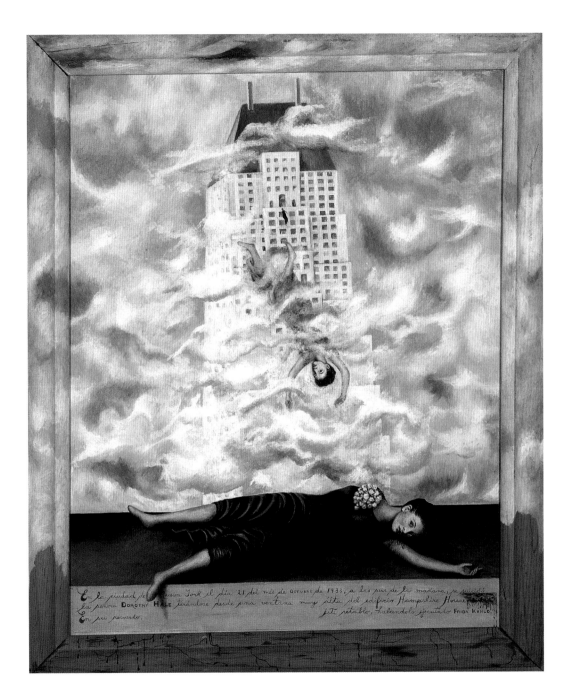

En la ciudad de _____ Nueva York el día 21 del mes de OCTUBRE de 1938, a las seis de la mañana, se suicidó la señora DOROTHY HALE tirándose desde una ventana muy alta del edificio Hampshire House. En su recuerdo. _____ este retablo, habiéndolo ejecutado FRIDA KAHLO.

Two Nudes in the Wood or The Earth or My Nurse and I, 1939

Oil on metal
25 × 30.5 cm
Mary-Anne Martin Collection / Fine Art, New York

1939 was an eventful year for Frida Kahlo, but it was also depressing and irksome. In Paris she came across the Surrealists, whom she described as "scoundrels", who "have something so false and fake about them that they make me mad". The fact that the Louvre purchased her picture *The Frame*, made her happy. After her return Kahlo left Rivera and moved out of their house in San Ángel. They were eventually divorced by mutual agreement. Her intimate relationship with Nickolas Muray also broke down (page 56).

Kahlo was under tremendous emotional pressure, which she wanted to express and compensate for in her painting. And so she produced this small-format, tranquil picture, which conjures up a harmonious world. The colour scheme and subjects of the picture seem familiar; everything radiates a relaxed calm. We find here the white-and-blue sky and the jungle backdrop as well as the earth which has been torn open, and in which Kahlo's "Mexican roots" can be seen. The artist's tame monkey Fuang-Chang peers out from between the leaves at what appears to be a "lovers' tryst". But the idyll is deceptive. Kahlo has painted herself as a split personality. The dark seated nude symbolises her Indian roots, while the wound on her thigh points to her suffering. The lighter reclining figure shows not only her European origins, but is also simultaneously her alter ego, always yearning for the opposite and with which she seeks reconciliation. She is determined to find peace with herself at last. Frida Kahlo had already painted herself on several occasions in similar fashion as a split personality, as also in *The Two Fridas* (page 39). She would do the same again in her late pictures, for example in *Tree of Hope, Keep Strong* from 1946 (page 43).

The Broken Column, 1944

Oil on canvas
40 × 30.5 cm
Dolores Olmedo Foundation, Mexico City

Carlos Fuentes, poet and diplomat, died in Paris in 2012 and was buried there in
the Cimetière du Montparnasse. He was not only a poet, but also a man who
appreciated art and who possessed a solid knowledge of art history. In his fore-
word to Frida Kahlo's diary he wrote:
"Frida Kahlo translated pain into art like no other artist of our oppressed century.
From the day of her accident to the day she died she had to endure 32 operations.
Her biography consists of 29 years of pain. From 1944 she had to wear eight corsets.
In 1953 her leg was amputated because it became gangrenous. Her injured back
oozed fluid and 'stank like a dead dog'. She was suspended naked by the feet to
strengthen her spine. She lost her foetuses in great pools of blood. She was con-
stantly surrounded by bloodstains, chloroform, bandages, needles, scalpels. She is
a Mexican St Sebastian, bound and pierced with arrows. She was the tragic embodi-
ment of Plato's highly plastic description: the body is the prison of the soul."

Flower of Life, 1944

Oil on hardboard
28 × 20 cm
Dolores Olmedo Foundation, Mexico City

This strange little picture was created in 1944 for the Salón de la Flor, the big annual flower show in Mexico City. Frida Kahlo had been invited along with other artists to submit flower still lifes which were to be exhibited during the event.

Most of them were realistic flower and plant still lifes, against which Kahlo's picture stood out. It is also unusual within Frida Kahlo's oeuvre. Many of her pictures show a sky divided between day and night. Here, however, it is uniformly dark; the red sun has no radiance, and instead of the moon, a flash of lightning flickers down towards the Earth. An anthropomorphic form grows out of the red leaves, with arms and blossom-like hands. A strand of seeds rises aloft and life is hurled upwards and outwards like an explosion. The picture thus fulfils exactly what its title promises. Moreover, its symmetry and monochrome colour scheme have something musical about them, so that the picture can also be interpreted as a hymn to life.

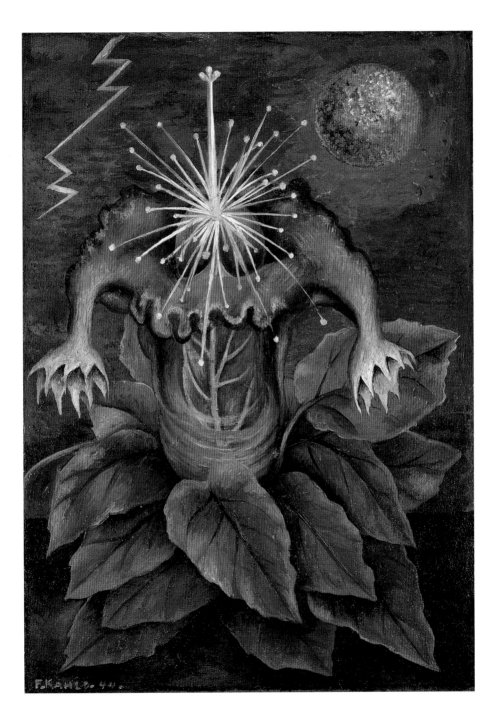

The Little Deer or The Wounded Deer or
I am a Poor Little Deer, 1946

Oil on hardboard
22.5 × 30 cm
Private collection, Houston, Texas

Frida Kahlo created only two paintings in 1946: *Tree of Hope, Keep Strong* (page 43) and *The Little Deer*. The content of the second picture appears easy to interpret, because Kahlo gave her own face to the body, which she shows as wounded by arrows and bleeding. The injured creature is hurrying through an utterly bleak, dead forest; a last green branch has been ripped off and is lying on the ground. If there is anything at all that can offer comfort here, then it is the view across the wide, endless ocean into eternity.

But it would not be a picture painted by Frida Kahlo if it did not offer us a number of other interpretations. Why has she painted herself in the form of a stag, as the antlers and testicles clearly indicate? Is it a reference to her bisexuality? Is it a coincidence that the antlers have nine points and the body has been pierced by nine arrows? Can we interpret it to mean that each time she was deceived by Rivera, each time she was "horned" by him like a cuckold, it would then appear as a bleeding wound? After all, Kahlo is bound to have been familiar with the figure of the "manticore", the "lion woman", a chimera of Persian origin with a lion's body and a human head. According to tradition the "manticore" or "mantigora" lived in the jungle and could speak but was the mortal enemy of man. So is the stag a symbol for the threat posed by her illness, which she had to overcome?

Despite this negative connotation, enormous strength and positive energy radiate from the leaping deer, do they not? Does it express Frida Kahlo's hope that after she had recovered from the major operation, she would be finally cured? To her last lover, the Catalan artist José Bartoli, she wrote from hospital: "I have the feeling that I have always loved you, since you were born and even before, when you were conceived. And sometimes it seems to me as if *you* had given me life!"

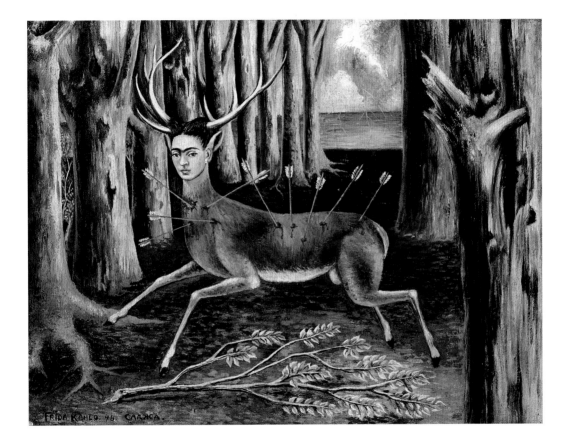

Diego and I, 1949

Oil on canvas
30 × 22 cm
Private collection, New York

In 1948 Diego Rivera asked his wife for a second divorce, because he wanted to marry the actress María Félix (page 63). Kahlo nonetheless painted another self-portrait in 1949 on which her husband is also to be seen again. We have already encountered the weeping "Friducha" in many self-portraits, but this one is particularly distressing: her hair is open and winds around her throat in a threatening manner. She is no longer wearing jewellery; there is no folklore, and no Tehuana headdress. Pure, naked, undisguised despair! But Diego Rivera is there too: on her brow, engraved into her thoughts. Her "god" has opened the third eye on his forehead; that is not a good omen. The Indian god Shiva was able to kill people with his third eye, but could also raise the dead back to life. What did Kahlo hope for or fear when she painted him with an open third eye? Will he bring her "resurrection" (in other words, heal her suffering)—or death? The fact that there could be no earthly "rebirth" for Frida Kahlo lay above all in the fact that she was not her partner's equal, either physically or intellectually. Rivera knew that all too well, and he manipulated her ruthlessly. The psychologist Salomon Grimberg arrived at the following assessment: "From the time that they met onwards, her personality changed in proportion to the degree to which she became involved in the relationship [...]: Kahlo began to behave as Rivera wished, to dress as he liked, to paint the way he wanted her to paint. In some respect she corresponded to Pygmalion's great artwork, the one he fell in love with. At the same time, Kahlo's transformation was tragic, because it permitted Rivera to shape her as he wished. He thoughtlessly demanded of her attitudes and behaviour which ultimately cost her dearly."

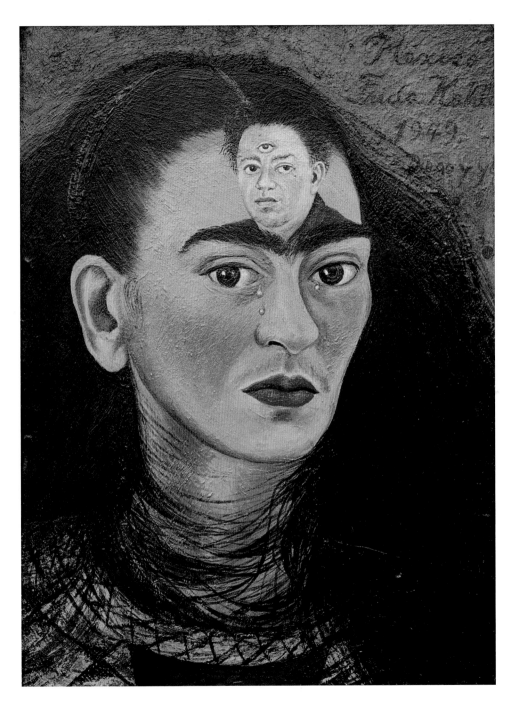

The Love Embrace of the Universe, The Earth (Mexico) I, Diego and Señor Xólotl, 1949

Oil on canvas
70 × 60.5 cm
Private collection, Mexico City

In *Diego and I* (page 102), Frida Kahlo lamented her shattered relationship with Rivera using sparse means, but clear-sightedly and with a degree of ruthlessness. Here, however, she returned in this panel painting to her dream and narrative pictures. As previously in *Tree of Hope, Keep Strong* from 1946 (page 43) and in earlier panel paintings, she has divided the picture into a daylight and a night scene. In the centre of the picture the artist is seated in traditional Indian dress and with her hair open. In her arms she is holding the all-knowing Rivera with his third eye like an infant. Behind Kahlo we recognise Mother Earth, whose eyebrows have grown together and recall those of the artist. In the distant background the Spirit of the Universe is visible between the clouds.

The dog-headed Xólotl was a god of vengeance, the Lord of the Evening Star and thus of the dark side of Venus, god of the underworld and the ruler over lightning bolts, death and misfortune. Here he has shrunk to the size of a lapdog that no one must be afraid of. It is much the same with the great Rivera. Kahlo has transformed the celebrated artist, the belligerent Marxist, the ruffian and womaniser into a helpless child, "her" infant!

"Diego is an immense baby with an amiable face and a slightly sad glance … seeing him nude, you immediately think of a young frog … His skin is greenish white like that of an aquatic animal."

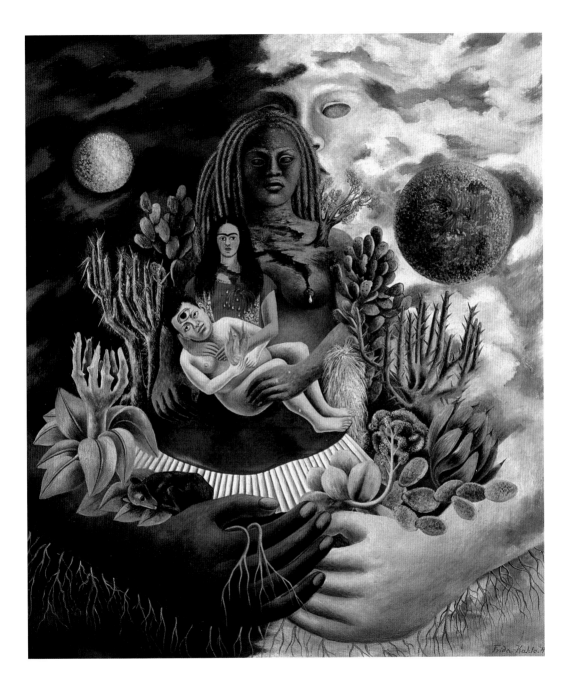

Self-Portrait with the Portrait of Dr. Farill, 1951

Oil on hardboard
42 × 50 cm
Private collection, Mexico City

In 1950 and 1951 Frida Kahlo had to undergo at least six operations on her spine in the "English Hospital" in Mexico City. The doctor in charge of her treatment, Dr. Juan Farill, was one of the best surgeons in Mexico, and Kahlo placed great hope in him. This may have been in part because Farill himself had to wear orthopaedic supports, so that Kahlo could regard him as a fellow-sufferer, a person to whom she felt close.

The room in which Kahlo is sitting in a wheelchair beside the portrait of her doctor is extremely austere. In her left hand she is holding a heart which has been cut open like a palette, and in her right a number of paintbrushes from which blood is dripping. She painted the portrait "with her lifeblood" and gave it to the doctor whom she admired, but whom she sometimes mockingly called a "bright spark". In her diary she wrote: "Dr. Farill saved me. He enabled me to enjoy life once more. I am still sitting in a wheelchair and do not know if I shall soon be able to walk again. I have a plaster corset and although it is a terrible torture, it helps me so that my back is better. I have no pain. I am simply dead tired, and of course I often despair."

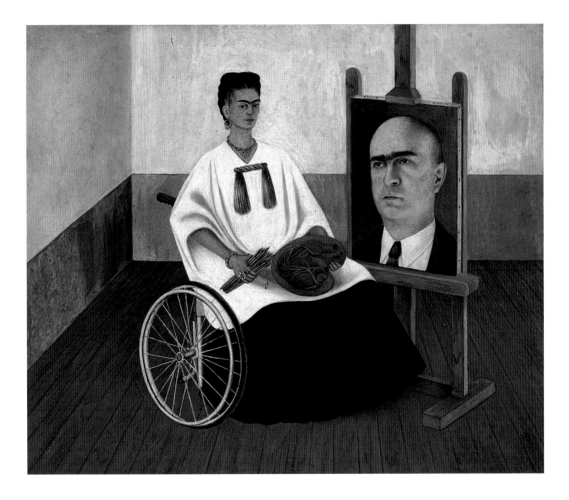

Viva la vida, 1954

Oil on hardboard
52 × 72 cm
Museo Frida Kahlo, Mexico City

In her last creative phase, from 1951 until her early death in 1954, Frida Kahlo dedicated herself above all to her diary and painted still lifes. Although she worried that her painting was not political enough and that she had not paid sufficient attention to the class struggle and the liberation of the working classes, she focused entirely on painting still lifes, which she called "life pictures".

Mostly the fruits were no longer arranged in dishes or on trays, but are lying—as also in this picture—on the ground in the open air. The colour schemes escalate into expressiveness and the forms of the fruits fill the entire picture surface. "A week before she died, when she only had a few hours left to live and the darkness began to envelop her, Frida dipped her paintbrush into blood-red paint and wrote across the crimson flesh of the foremost fruit her name and the date and place where the painting had been created. And then she set her final greeting to life in large letters above it: VIVA LA VIDA."

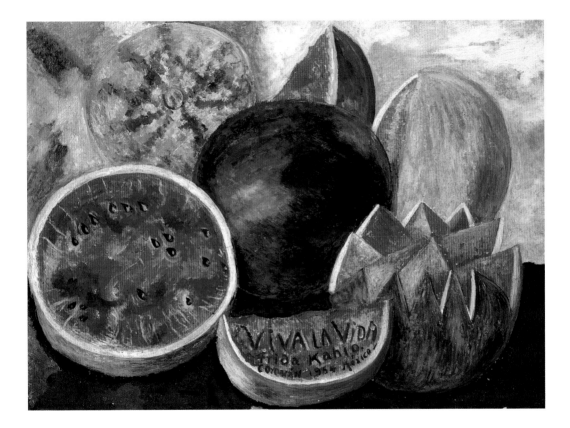

FURTHER READING

Alcántara, Isabel and Egnolff, Sandra, *Frida Kahlo and Diego Rivera*, Munich 2011

Bauer, Claudia, *Frida Kahlo*, Munich 2014

Chicago, Judy, *Frida Kahlo: Face to Face*, New York 2010

Fuentes, Carlos, *The Diary of Frida Kahlo. An Intimate Self-Portrait*, New York 2005

Genschow, Karen, *Frida Kahlo*, Frankfurt am Main 2007

Grimberg, Salomon, *I will Never Forget You ... Frida Kahlo to Nickolas Muray*, London 2005

Grimberg, Salomon (ed.), *Frida Kahlo. Song of Herself*, London 2008

Herrera, Hayden, *Frida Kahlo. The Paintings*, New York 2002

Herrera, Hayden, *Frida: A Biography of Frida Kahlo*, New York 2002

Kahlo, Frida, *Dir sende ich mein ganzes Herz. Liebesbriefe*, Foreword by Raquel Tibol, Munich 2004

Priegnitz-Poda, Helga, *Frida Kahlo. Verschollene, zerstörte und kaum gezeigte Bilder*, Munich 2017

Schmied, Wieland, *Zweihundert Jahre phantastische Malerei*, Berlin 1973

Tibol, Raquel, *Frida Kahlo: An Open Life*, Albuquerque 1993

Wilcox, Claire, *Frida Kahlo Making Her Self Up*, London 2018

PHOTO CREDITS